IMAGES
of America

MOFFETT FIELD

ON THE COVER: *Macon* is towed out of Hangar No. 1 through the south doors, which face Highway 101, while tethered to the mooring mast. The mast rode on railroad tracks and was used to move the dirigible to mooring circles at either end of the hangar. (Courtesy U.S. Navy.)

IMAGES
of America

MOFFETT FIELD

Nicholas A. Veronico

ARCADIA
PUBLISHING

Published by Arcadia Publishing
Charleston SC, Chicago IL, Portsmouth NH, San Francisco CA

Printed in the United States of America

Library of Congress Catalog Card Number: 2006920969

For all general information contact Arcadia Publishing at:
Telephone 843-853-2070
Fax 843-853-0044
E-mail sales@arcadiapublishing.com
For customer service and orders:
Toll-Free 1-888-313-2665

Visit us on the Internet at www.arcadiapublishing.com

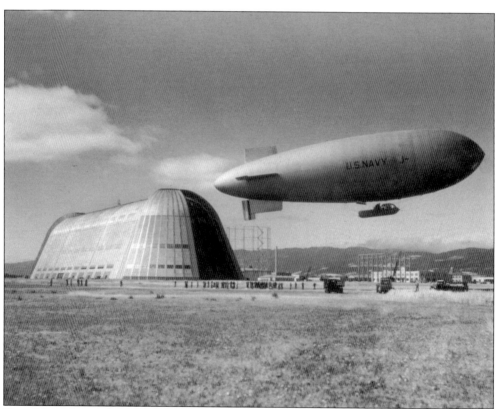

Navy blimp J-4 made its first flight from NAS Sunnyvale on June 27, 1933. This airship was transferred to the West Coast from NAS Lakehurst, New Jersey, and was built in 1927. J-4 was 196 feet long and had a gas volume of 210,600 cubic feet. (U.S. Navy.)

CONTENTS

ACKNOWLEDGMENTS

Special thanks go to the Moffett Field Museum. This book would not have been possible without the museum granting generous access to its collection. Thanks to their staff and volunteers, including Carol Henderson (museum founder), David Black, R. S. "Red" Brooks, Kay Case, Eugene "Frenchie" Chocniere, Bernie McDonough, Gloria Perlett, Zoltan Szobozlay, William Stubkjaer, and the late Lt. Comdr. George Carroll (who was the navy photographer responsible for the majority of the *Macon* photographs). More information on the Moffett Field Museum is available online at www.moffettfieldmuseum.org.

In addition, the staffs of the following organizations contributed greatly to this effort: NASA Ames Research Center Public Affairs, NASA Ames History Office, California Air National Guard, and Planners Collaborative. If you are interested in any of the NASA technologies showcased in this volume, details can be found at www.nasa.gov.

A number of individuals supported the effort to gather photographs and other information, and I would like to express my gratitude to: Ian Abbott; Caroline and Ray Bingham; Roger Cain; Brett Casadonte; Jeff Cross; Ed Davies; Maylene Duenas; Jim Dunn; the family of Herman Ewald Finell (Rebecca Moon), who shot some of the early Hangar No. 1 construction photographs; Ron Gerdes; Kevin Grantham; Gaye Graves; Andrew Hughan; Julie Jervis; Buddy Joyce; Norm Jukes; Tillie and William T. Larkins; Al Ludlow; Jim Lund; Thomas William McGarry; Wayne McPherson Gomes; Michael D. Makinen; Michael H. Marlow; Gina Morello; Dan Morgan; Pat and Jerry O'Connell; David G. Robertson; Doug Scroggins; Arthur E. Sevigny (20th Fighter Wing Association historian); Phil So; Jim Taylor; Scott Thompson; Richard H. VanderMeulen; Betty S. Veronico; Karen and Armand Veronico; Tony Veronico; and Hannah Clayborn and the staff of Arcadia Publishing.

Please note that this is not an official publication of NASA, the U.S. Navy, the California Air National Guard, or the Moffett Field Museum, and any opinions expressed or errors in content are the responsibility of the author.

—Nicholas A. Veronico
San Carlos, California

INTRODUCTION

The 2,325 acres along the southern shoreline of San Francisco Bay represent many things to a variety of people. Some only see the massive black and gray Hangar No. 1 as they pass by on Highway 101. Others see the airfield and Hangars No. 2 and No. 3, the twin wooden blimp hangars on the eastern side of the field. Further north, along Highway 101, can be seen the world's largest wind tunnel, emblazoned with the words "NASA Ames Research Center."

Each of the areas visible from the freeway represents three distinct eras of accomplishment and changes in technology. Hangar No. 1 symbolizes aviation's golden age, when dirigibles offered luxurious air travel to commercial passengers and became the eyes of the fleet as flying aircraft carriers in the early 1920s. Hangars No. 2 and No. 3 bring to mind a time when the world was at war, and Moffett Field was one of the West Coast's training bases for fledgling military aviators. In the cold war, Moffett Field and its massive hangars were home to the U.S. Navy's West Coast-based patrol squadrons. Flying four-engine Lockheed P-3 Orions, crews patrolled the Pacific in search of Soviet submarines. The California Air National Guard's 129th Air Rescue Wing is also located on the eastern side of the field. The men and women of the 129th serve in war and peace, dedicated to saving lives whether in a combat situation, a natural disaster, or rescuing seafarers far off the California coast.

The NASA Ames Research Center, which occupies the northwest quadrant of the Moffett Field complex, had been a tenant of the navy from 1939 to 1994. When the navy pulled out of Moffett Field in July 1994, NASA became responsible for airfield operations and management of the now-vacant navy property. Under NASA's stewardship, the navy property is being transformed into the NASA Research Park, where high-tech businesses and academia can collaborate with the space agency. Buildings on the former navy base, with their fantastic Spanish Colonial–Revival architecture, have been given a new lease on life. The parade ground area has been designated the Shenandoah Plaza historical district.

Ames Research Center has been at the forefront of aerospace technology since its inception in 1939. Yet few know that behind the wind tunnels are researchers exploring the frontiers of supercomputing, human factors, robotics, space sciences, astrobiology, nanotechnology, and thermal protection systems. This research center, in many ways hidden from public view, has made far-reaching contributions to both aeronautics and space flight for more than six decades.

The Images of America series enables a glimpse into the history of Moffett Field and NASA Ames Research Center, and in many ways recognizes the contributions made by so many men and women who have served at both institutions.

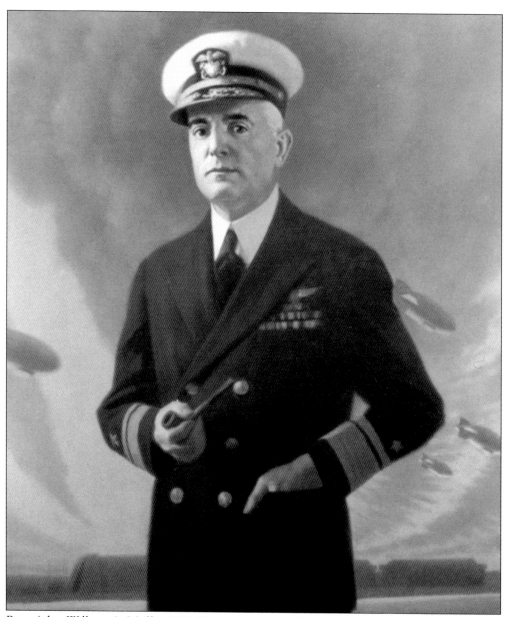

Rear Adm. William A. Moffett, U.S. Navy, was born on October 31, 1869, in Charleston, South Carolina. He began his naval career as a cadet on September 6, 1886, and served as an ensign during the Battle of Manila Bay. Admiral Dewey subsequently appointed Moffett as captain of the Port of Manila. Later, as commander of the cruiser *Chester*, Moffett was awarded the Medal of Honor for his actions during the Battle of Vera Cruz. In 1921, he became director of Naval Aviation and the first chief of the Bureau of Aeronautics. He perished at sea on April 4, 1933, in the crash of the dirigible USS *Akron*. (Courtesy U.S. Navy.)

One

NAVAL AIR STATION SUNNYVALE AND THE USS MACON

Giant, lighter-than-air flying craft cruising across oceans as commercial transports and as military aircraft carriers scouting the seas for the enemy fleet, held great promise in the early 1920s. The Germans had demonstrated the military utility of dirigibles during the First World War, highlighted when they sent 11 of the craft to bomb England on October 19, 1917. A Zeppelin L-49 was captured by the Allies and studied in detail.

From the lessons learned with L-49 and other spoils of war, the U.S. Navy began its own dirigible program. ZR-1 *Shenandoah* was designed and prefabricated at the Naval Aircraft Factory in Philadelphia and assembled in the newly built hangars at Naval Air Station Lakehurst, New Jersey. *Shenandoah* first flew on September 4, 1923, and was soon joined by a sister ship, ZR-3 *Los Angeles*. The lessons learned in building ZR-1 and ZR-3 went into the design and construction of ZRS-4 USS *Akron* and ZRS-5 USS *Macon*. In addition, the knowledge gained working with aluminum was also transferred to the fledgling aircraft industry.

As the decade of the 1920s came to a close, the navy began searching for a suitable West Coast base of operations for *Macon*. It came down to Kearny Mesa, near San Diego, or a site in the San Francisco Bay area. The region's chambers of commerce knew the positive impact that a naval base would have on the area's economy, and they quickly began searching for a suitable site. Credit for the site is given to Laura Thane Whipple, a real estate agent, who suggested the 1,700-acre parcel on the Sunnyvale/Mountain View border known as the Ynigo Ranch. As the world entered the Great Depression, $476,065 was raised and 1,000 acres of land purchased, but the navy had still not made a commitment, even though the land would be deeded to the navy for $1. President Hoover signed the bill authorizing the navy to receive the land on February 20, 1931.

Construction of the new navy base, to be known as Naval Air Station (NAS) Sunnyvale, began in October 1931. With it came $5 million for materials and labor. The gamble paid off.

As the base was being built, ZRS-4 *Akron* crashed off the New Jersey coast on April 4, 1933, taking 74 souls, among them Rear Adm. William A. Moffett, the first chief of the Bureau of Aeronautics. On April 12, NAS *Sunnyvale* was commissioned, and to honor the fallen admiral, the landing area of the air station was named Moffett Field. On October 16, 1933, *Macon* arrived to take up residence in Hangar No. 1.

Hangar No. 1, which dominates the skyline in the South Bay, was built to house the *Macon*, and subsequent larger dirigibles that navy officials anticipated would be put into service. Built in the Streamline Moderne, art deco style, the building could house the *Macon* as well as two of the later L-ship blimps simultaneously. A recent comparison drawing shows three RMS *Titanic* ocean liners side by side in Hangar No. 1, with room to spare at both ends. Hangar No. 1 is 1,138-feet long, 308 feet wide, and 210 feet to the top of the roof, and covers 351,000 square feet.

Macon operated from Moffett Field for only 16 months. The top damaged tail fin had not been fully repaired when the dirigible set off for operations with the Pacific fleet on February 11, 1935. The airship went down the following day in a storm off Point Sur, California. Although 81 officers and airmen were rescued, two crewmembers were lost in the accident.

With its prime tenant at the bottom of the Pacific, the navy sought a use for the air station. In a trade with the U.S. Army, Moffett Field was exchanged for the base at North Island, near San Diego, California; Ford Island at Pearl Harbor, Hawaii; and Bolling Field near Washington, D.C.

With the army came fixed-wing aircraft from the 82nd Army Observation Squadron. In 1938 and 1939, the Curtiss P-36 Hawk arrived with the 20th and 35th Pursuit Groups. Aircraft from these Moffett-based squadrons could be seen up and down the West Coast as war clouds gathered on the horizon.

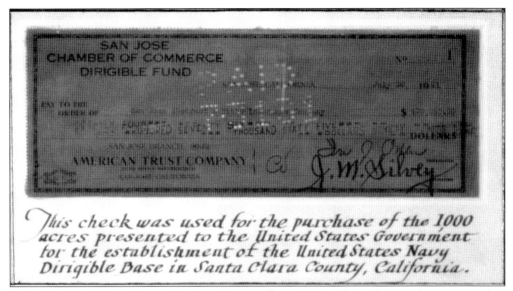

The San Jose Chamber of Commerce was the collection point for gathering the money to buy the land that would become Moffett Field. The check is in the amount of $476,065. (Courtesy Moffett Field Museum.)

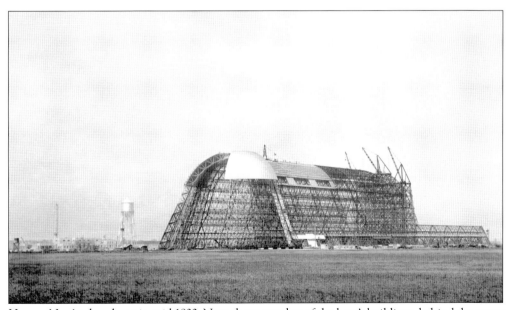

Hangar No. 1 takes shape in mid-1933. Note that a number of the base's buildings, behind the water tower, appear to be complete. Hangar No. 1's framework is 60 percent complete, and skins are being installed over the doors and the hangar's southern end. (Courtesy Herman Ewald Finell.)

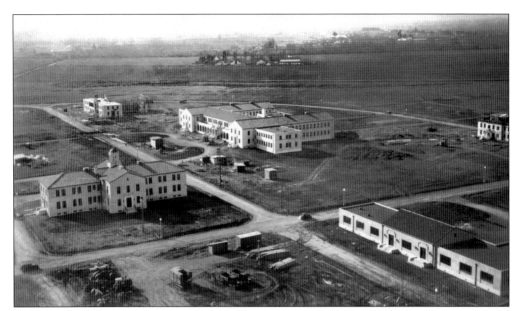

Building No. 17, base operations with the bell tower (center left), was the first building completed at Naval Air Station Sunnyvale. The vehicles traveling from left to right are on McCord Avenue. Building No. 25, top; Building No. 19, center; and Building No. 14, lower right; all front North Akron Road. Building No. 2, the aerology and communications station, can be seen under construction to the right. (Courtesy Herman Ewald Finell.)

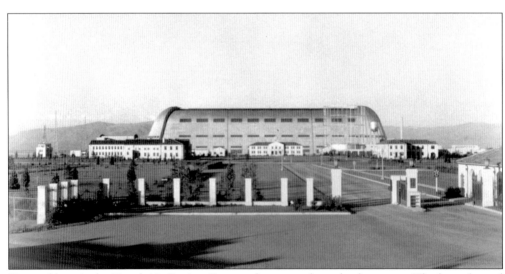

Pictured here is the Naval Air Station Sunnyvale as seen from the front gate. The large framed structure near the water tower is the base's helium storage tank, which would rise or fall depending upon gas levels. (Courtesy U.S. Navy.)

On April 1, 1943, road improvements were being made on the base's south side. (Courtesy U.S. Navy.)

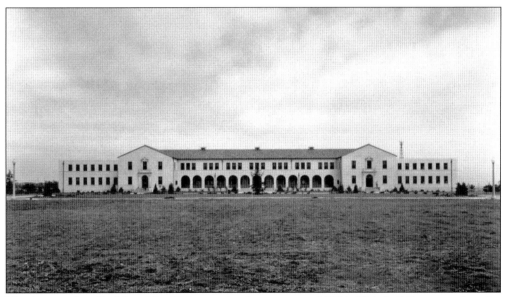

Nearly complete Building No. 19 is seen in the summer of 1934. This building served as the bachelor enlisted quarters and housed the base brig in the basement. (Courtesy U.S. Navy.)

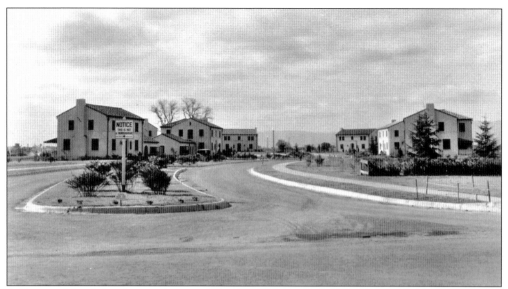

Officers at Naval Air Station Sunnyvale were afforded spacious accommodations, as this April 1934 view looking into the cul de sac shows. (Courtesy U.S. Navy.)

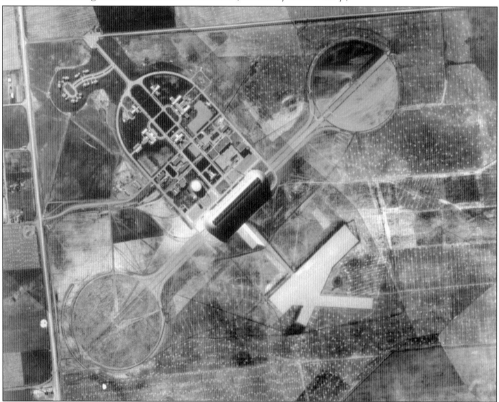

This aerial view of Naval Air Station Sunnyvale was shot in 1934. From the top can be seen the main gate and officer's housing at the first right turn, with the main entrance road opening to Shenandoah Plaza. Note the railroad tracks leading from Hangar No. 1 to the north (right) and south mooring circles, as well as the landing strip to the east. (Courtesy U.S. Navy.)

Building No. 3, the aerological station, is a three-story, 3,700-square foot building with radio mast on top and to the left and right of the building. Note the weather station located directly across the street. (Courtesy U.S. Navy.)

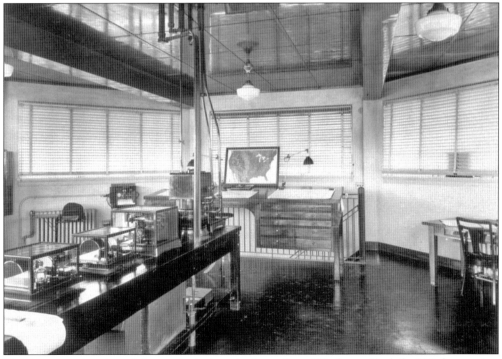

This is an interior view of the aerological station's top floor. Windows afforded a 360-degree view of the air station. (Courtesy U.S. Navy.)

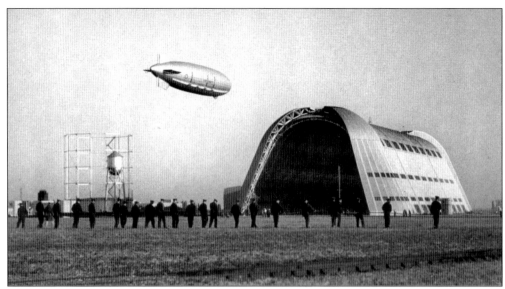

On October 5, 1934, the USS *Macon* (ZRS-5) arrives from Opa Locka, Florida. At the time, the dirigible was a technological marvel, with thousands turning out to watch the airship's arrival. The *Macon* would operate in the Bay Area for the next four months before crashing into the Pacific on February 12, 1935. (Courtesy U.S. Navy.)

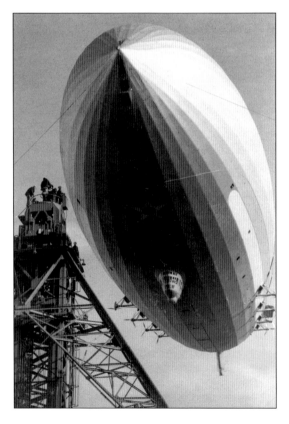

The USS *Macon* approaches the mooring mast at NAS Sunnyvale upon its arrival from the East Coast. Note the sailors precariously perched atop the mast to help guide the airship into position. (Courtesy U.S. Navy.)

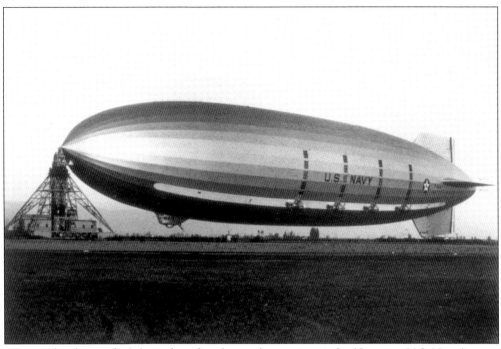

Macon rides the wind while anchored at the south mooring circle. (Courtesy U.S. Navy.)

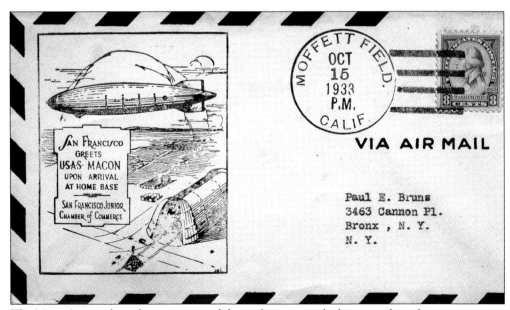

The *Macon*'s arrival was big news up and down the coast and a huge number of commemorative items were dedicated to it, including first day covers issued as fund-raisers. This example was sold by the San Francisco Junior Chamber of Commerce. (Courtesy author.)

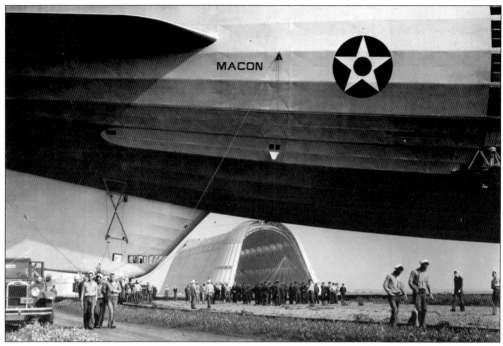

After mooring, *Macon* weathervanes on the south mooring circle, located closest to today's Highway 101. Note the steering compartment located in the lower ventral fin and the large number of sailors required to manhandle the airship onto the ground. (Courtesy U.S. Navy.)

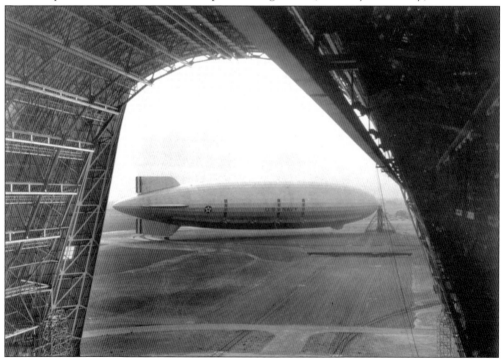

The *Macon* is seen here on the mooring mast in October 1934 through the doors of Hanger No 1. (Courtesy U.S. Navy.)

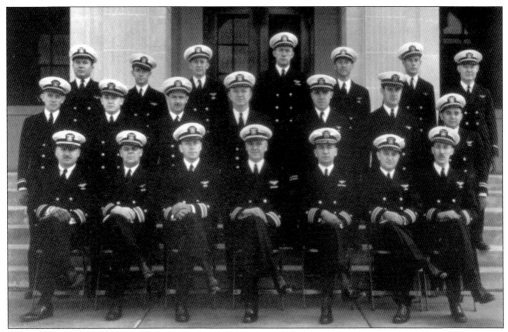

This February 1935 view of the officer compliment of the *Macon* in front of Building No. 17 was just days before the dirigible was lost off Big Sur, California. (Courtesy U.S. Navy.)

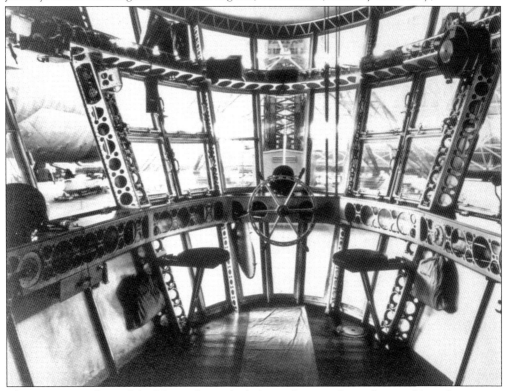

The main control car of the *Macon* shows the helm at the most forward point. Note the unique-looking duralumin truss system used to construct the airship's frame. (Courtesy U.S. Navy.)

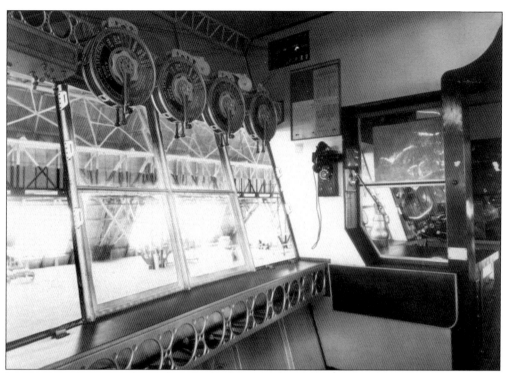

Engine controls were on the starboard side of the main control car. Note the rigging for the engine controls going up into the bulkhead. (Courtesy U.S. Navy.)

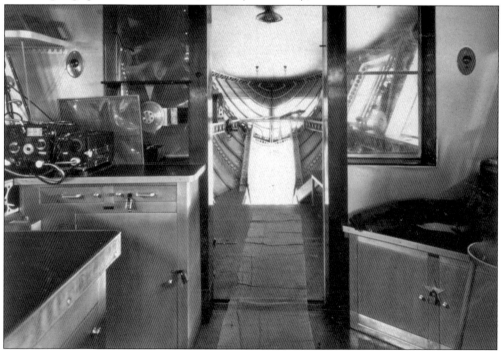

Looking aft through the navigator's compartment to the air stairs, radios are located on the left against the bulkhead, and the navigator's chart table is in the left foreground. (Courtesy U.S. Navy.)

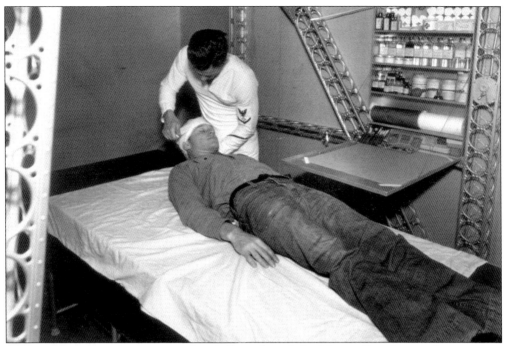

A pharmacist mate demonstrates his skills on board the *Macon*. Based upon the extensive medical kit on the bulkhead, the navy must not have thought there would be anything more than superficial wounds to dress. (Courtesy U.S. Navy.)

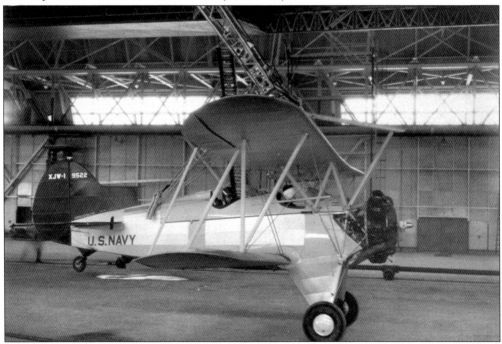

Waco XJW-1, Bureau No. 9522, was used to demonstrate the transfer of an injured sailor. The sailor is seated in the front with the pilot in the rear, and the aircraft was lowered from the *Macon's* hangar bay, all while the airship rested in Hangar No. 1. (Courtesy U.S. Navy.)

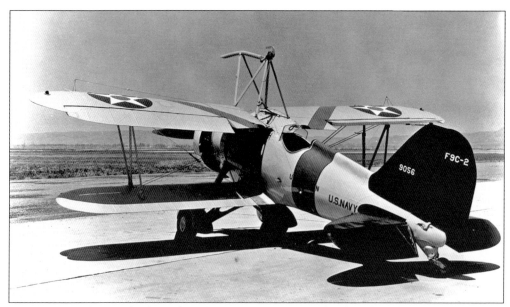

Bureau No. 9056 was the first of six Curtiss F9C-2 Sparrowhawk fighters built specifically for airship operations. For recovery and deployment of aircraft from the *Macon*, the Sparrowhawks hooked onto the airship's trapeze and were lifted into the hangar bay. (Courtesy U.S. Navy.)

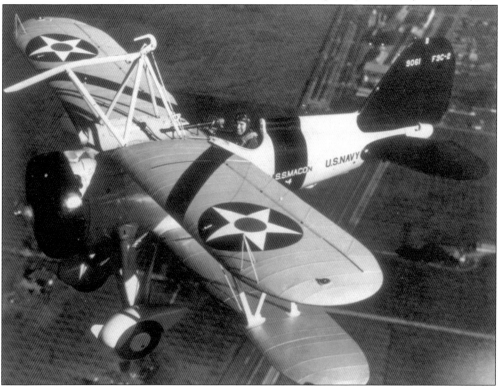

Air-to-air study of Curtiss F9C-2, Bureau No. 9061, was performed over the citrus groves of Sunnyvale. Note the telescopic sight ahead of the pilot that protrudes through the windscreen. (Courtesy U.S. Navy.)

An F9C-2 has hooked the *Macon's* trapeze. The wishbone at the back of the trapeze will connect with the aircraft's rear fuselage to stabilize it when being pulled into the hangar bay. The *Macon's* hangar bay could accommodate five aircraft and was 75-feet long, 60-feet wide, and 16-feet tall. (Courtesy U.S. Navy.)

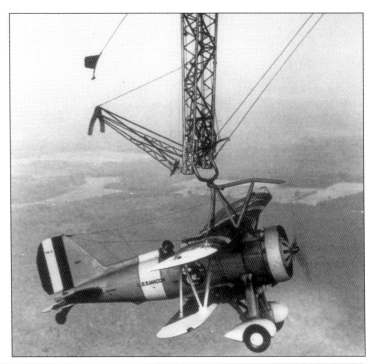

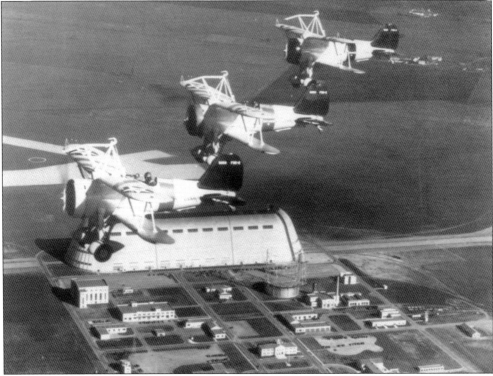

Three of the *Macon's* Sparrowhawks pass in review over Naval Air Station Sunnyvale. Note the number of support buildings that have sprung up. Building No. 3, the free balloon hangar, has been completed. (Courtesy U.S. Navy.)

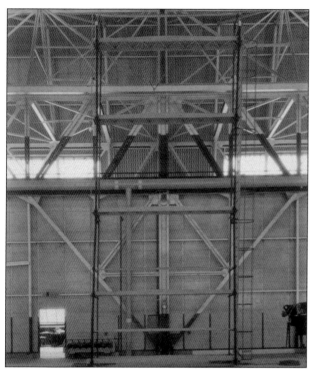

Doping scaffold used to maintain the airship's outer covering was positioned in Hangar No. 1. The scaffold reached 65 feet. (Courtesy U.S. Navy.)

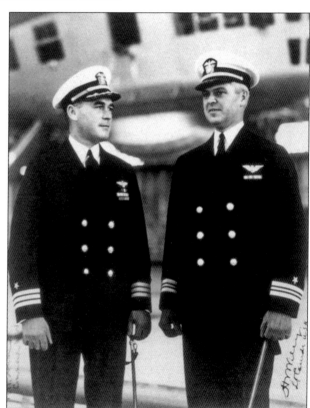

Comdr. Alger H. Dresel, left, commanded the *Macon* from 1933 to 1934. Dresel is seen turning over command of ZRS-5 to Lt. Comdr. Herbert V. Wiley in June 1934. (Courtesy U.S. Navy.)

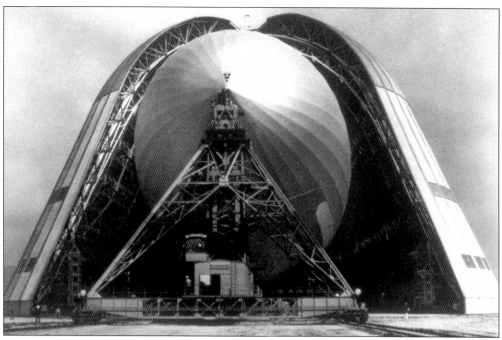

Under cloudy skies, *Macon* is moved out of Hangar No. 1 on the rolling mast to the south mooring circle. (Courtesy U.S. Navy.)

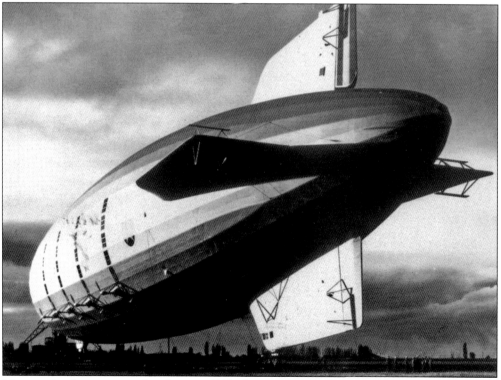

Macon rides the mast on a late January 1935 afternoon. Note the size of the fins and rudders in comparison to the sailors at right. (Courtesy U.S. Navy.)

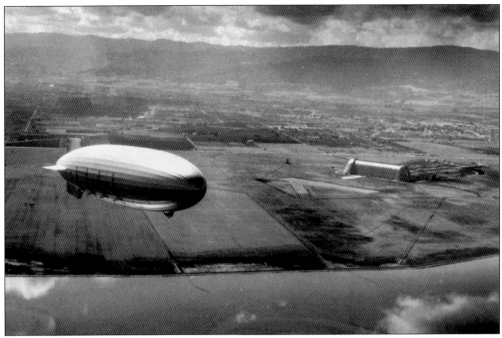

Macon works its way north after departing NAS Sunnyvale at midday. Note the population density in the Santa Clara Valley and how the base is surrounded by farmlands. (Courtesy U.S. Navy.)

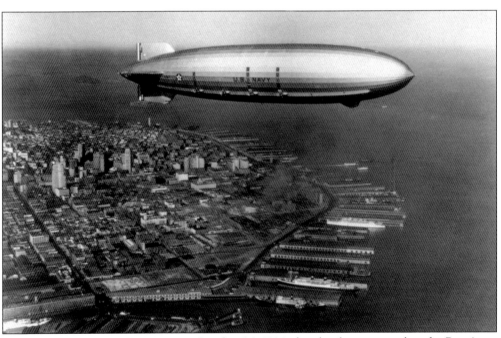

Macon cruises over San Francisco on October 26, 1934, shortly after its arrival in the Bay Area. One of the first supports for the San Francisco Bay Bridge is visible under the airship's nose. (Courtesy U.S. Navy.)

The *San Francisco Examiner* detailed the harrowing escape of the *Macon*'s crew and told the commander's story through an artist's rendition of the crash. (Courtesy Moffett Field Museum collection.)

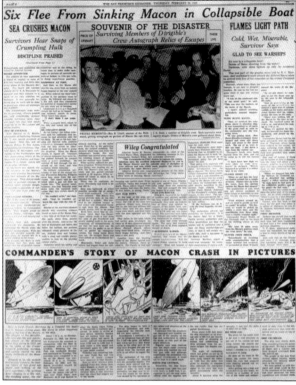

Surviving the *Macon* crash was a true adventure, and the survivors autographed everything. This photograph was taken in the days after the accident in front of Hangar No. 1, with one of the *Macon*'s lifeboats. (Courtesy U.S. Navy.)

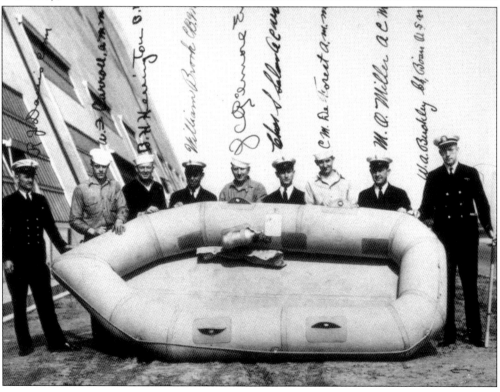

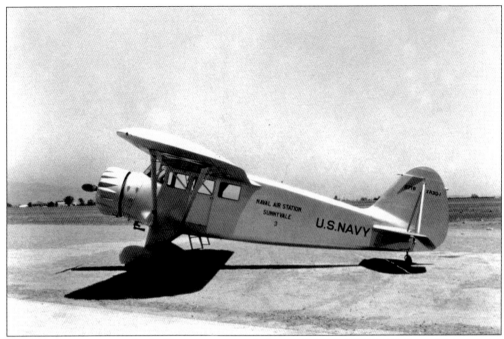

The air station commander had his own personal plane, a Stinson XR3Q-1 Reliant. This was the only example of this type of aircraft to see service with the navy. Note the "Naval Air Station Sunnyvale" markings. (Courtesy U.S. Navy.)

Douglas Y1O-43 (serial No. 32-293) from the Moffett Field–based 82nd Observation Squadron is seen parked at the San Francisco Bay Aerodrome in 1938. Note the intricate parasol wing. (Courtesy William T. Larkins.)

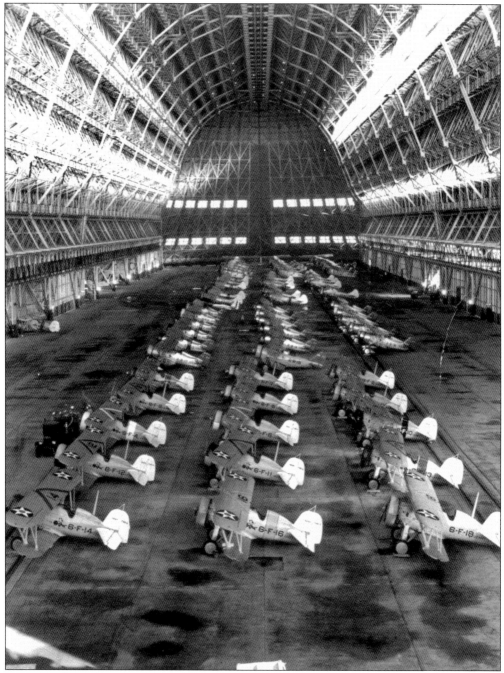

Navy squadrons VF-6, VB-2, VS-2, and VT-2 are parked in Hangar No. 1, c. 1935. The view in this photograph looks south. (Courtesy U.S. Navy.)

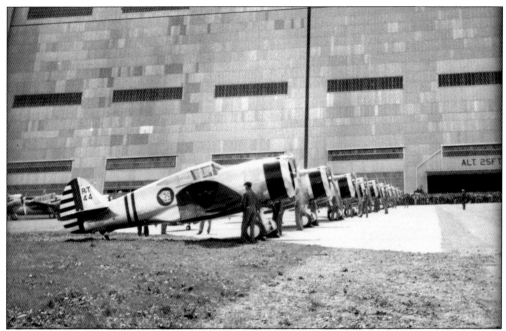

On November 20, 1939, the 20th Pursuit Group completed its transfer from Barksdale Field, Shreveport, Louisiana, to Moffett Field. More than 65 officers and 350 enlisted men of the 20th now called Moffett Field home, and with them came the group's Curtiss P-36 Hawks, seen ready for inspection outside Hangar No. 1. The aircraft to the left are North American O-47s of the 82nd Observation Squadron. (Courtesy 20th Fighter Wing Association.)

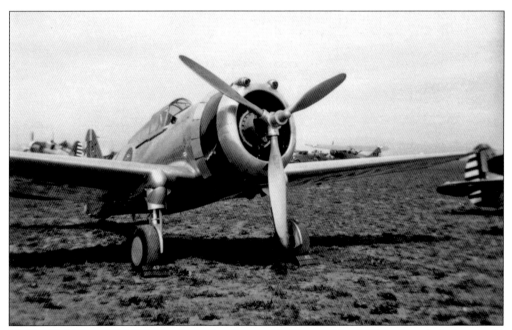

Moffett Field–based P-36 Hawks sit on the dirt outside Hangar No. 1. This aircraft design would later evolve into the Curtiss P-40, typically seen with shark's mouth and often related to the Flying Tigers in China. (Courtesy 20th Fighter Wing Association.)

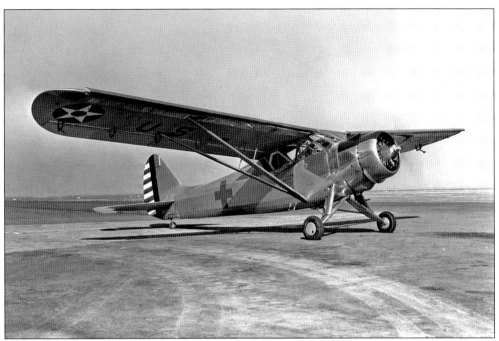

This is a rare view of the Stinson O-49B Vigilant airborne ambulance on the tarmac at Moffett Field on December 6, 1941. The aircraft was painted silver with red crosses. Four O-49Bs were converted from the 182 O-49As built. (Courtesy William T. Larkins.)

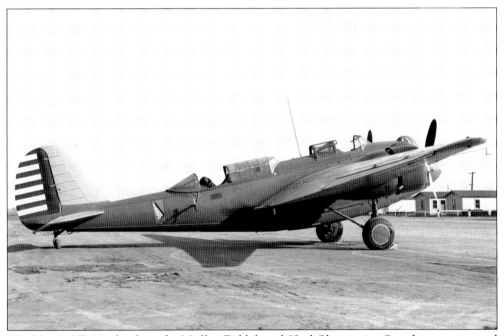

The Martin YB-10, also from the Moffett Field–based 82nd Observation Squadron, was crewed by a pilot, dorsal gunner/radio operator, and nose gunner/bombardier and could carry a 2,260-pound bomb load. The aircraft was powered by two 675 horsepower R-1820-25 radial engines. (Courtesy William T. Larkins collection.)

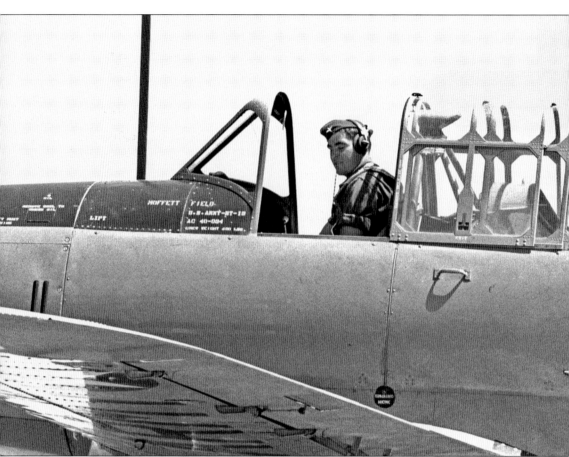

With war on the horizon, the need to train aviators increased. Moffett Field became home to the Army Air Corps West Coast training headquarters, the flying BT-13s. This September 1941 photograph shows the BT-13, serial No. 40-934, about to be soloed by a cadet. Notice that the aircraft's base, Moffett Field, has been stenciled above the data block. (Courtesy William T. Larkins.)

Two

Naval Operations During World War II

Even though the *Macon* was gone, the airship's legacy would live on at Moffett Field during World War II. The December 7, 1941, attack on the United States at Pearl Harbor thrust America into war, and the navy needed airships to patrol its coasts and escort ship convoys.

The need for coastal patrol was driven home when the Japanese submarine *I-23* attacked the Richfield Oil Company tanker *Agwiworld* in Monterrey Bay on December 20, 1941. The sub pursued *Agwiworld* into the Santa Cruz harbor before giving up the chase. The SS *Emidio* and SS *Montebello* were sunk, and other ships along the California coast were attacked by Japanese submarines during the closing days of December 1941.

In January 1942, the first blimps began arriving at the base for the first West Coast airship squadron, ZP-32, formed at Moffett Field. Using two ex-U.S. Army blimps, TC-13 and TC-14, ZP-32 made its first flight on February 4. As the blimp squadron worked up to full strength, it began to deal with the Japanese submarine menace, climaxing in the February 23 shelling of the oil derricks at Ellwood, near Goleta, California. ZP-32 blimps looked for the sub, *I-17*, but were too far behind to pursue her.

Naval Air Station Sunnyvale was officially commissioned on April 16, 1942, and its name changed to Naval Air Station Moffett Field on April 20. In mid-1942, contracts for two additional blimp hangars were let. Both would be of wood construction with concrete bases and shops and offices lining the foundations of both walls. Known as Hangars No. 2 and No. 3, they were situated on the east side of the field, oriented north to south. Hangar No. 2, encompassing 347,000 square feet of floor space, was built in a little over one year—372 days. Hangar No. 3, wider than Hangar No. 2, covers 434,000 square feet and, benefiting from the infrastructure used to construct Hangar No. 2, was completed in 208 days.

Lighter-than-air (LTA) pilots were first instructed in the theory of LTA flight, then trained to fly "free balloons." Like the hot air balloons of today, free balloons drift on wind currents, with the pilot controlling the rate of ascent or descent. Balloons were inflated and occasionally test flown inside Hangar No. 1, although the majority of free balloon operations were conducted out of what is today known as Building No. 2. Essentially a free balloon hangar, the building's footprint is 130 feet wide by 88 feet deep, and it measures 63 feet to the top of the roof. A hydrogen plant

was constructed on the west side of Building No. 2, with pipes going into the building to aid in filling the training balloons.

L-ships, blimps that were 149 feet in length with a gas volume of 123,000 cubic feet, were used to train LTA crews in primary blimp flight and handling skills. Auxiliary blimp fields under the control of Moffett Field were established at Eureka and Watsonville, California, in August 1943 to provide satellite bases to extend operations north and south, respectively, in the San Francisco Bay area.

As the end of the war approached and the threat of Japanese submarines off the West Coast declined, LTA operations started to wind down and heavier-than-air squadrons began to move to Moffett Field. Patrol squadrons flying PV-1 Venturas began to take space on the Moffett ramp, as did nine Martin JM Marauders (Army B-26s) used to tow targets for navy gunners. The Japanese surrender in September 1945 sounded the death knell for airship operations at Moffett Field.

On April 20, 1943, Heple Contractors' pile driver is in action at Naval Air Station Moffett Field. Although it looked rickety, this pile driver set the piles for all eight corners of Hangars No. 2 and No. 3. (Courtesy U.S. Navy.)

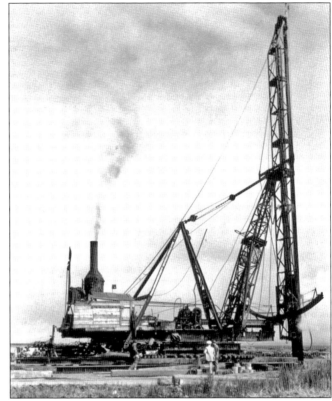

Door tower piles for Hangar No. 3's southeast corner undergo a 60-ton test on April 29, 1943. The contractor for Hangars No. 2 and No. 3 was Earle W. Heple and J. H. Pomeroy Incorporated. (Courtesy U.S. Navy.)

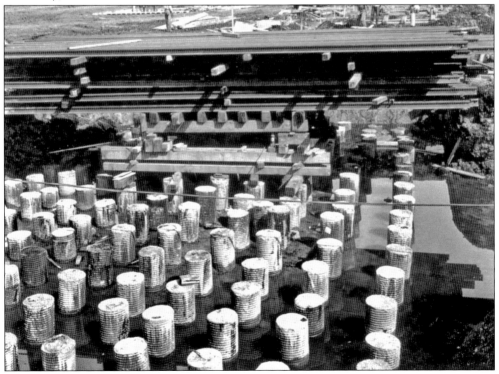

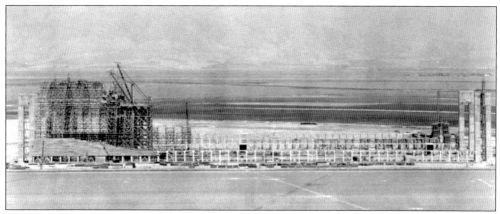

This May 28, 1943, view shows the construction progress of Hangar No. 2 from atop Hangar No. 1. (Courtesy U.S. Navy.)

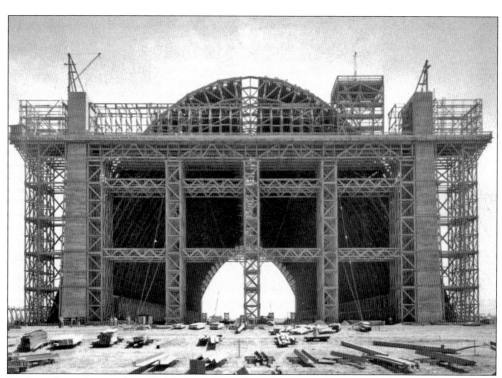

Looking from the north end of Hangar No. 2 on July 14, 1943, into the building shows the box girder construction of the arch. (Courtesy U.S. Navy.)

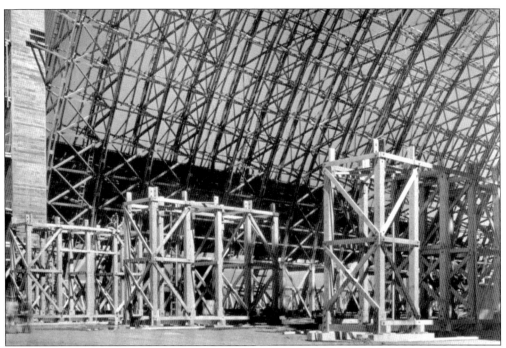

On June 2, 1943, workers began erecting the scaffolding for hanging the door track in Hangar No. 2. Note the intricate framework of the hangar arch. (Courtesy U.S. Navy.)

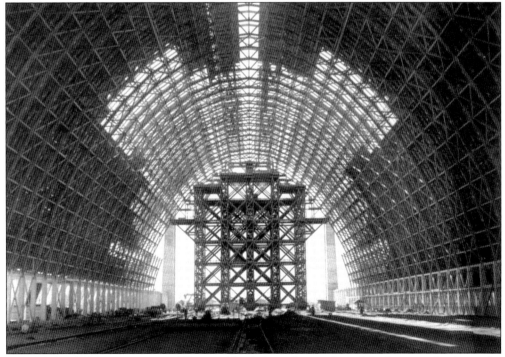

A June 28, 1943, interior view of Hangar No. 2 from the north end, looking south, shows the traveler gantry used by workers to complete the arch. (Courtesy U.S. Navy.)

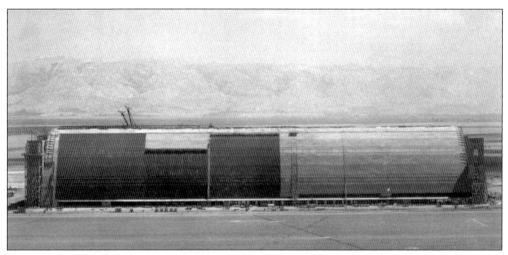

On July 20, 1943, this photograph of Hangar No. 2, viewed from atop Hangar No. 1, shows the exterior skin being placed onto the framework. (Courtesy U.S. Navy.)

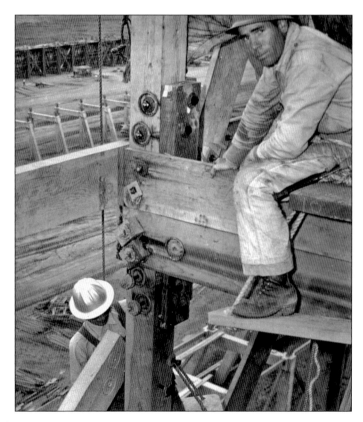

Workers change a support on the traveler in Hangar No. 2, with construction of Hangar No. 3 underway in the background. (Courtesy U.S. Navy.)

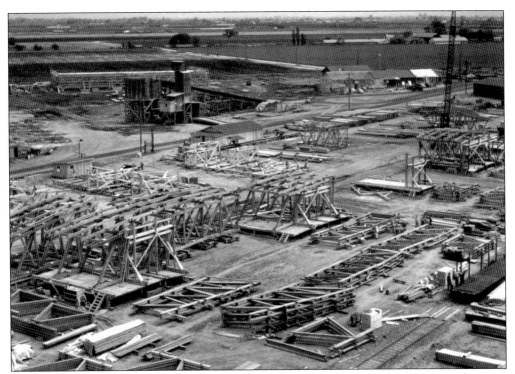

During World War II, the assembly line process was extended to aircraft, ships, and even hangars. In the area south of Hangars No. 2 and No. 3, an assembly line was set up to prefabricate trusses, which were then moved below the traveler gantry and lifted into place by a crane. (Courtesy U.S. Navy.)

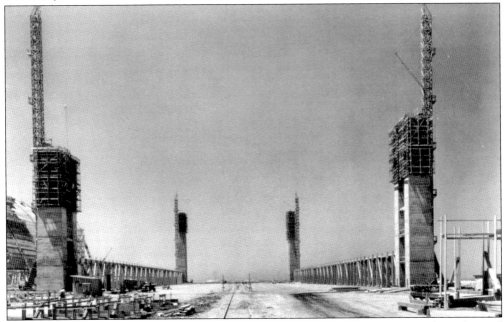

Hangar No. 3's foundation is ready on both sides, and the corner supports are inching skyward on June 17, 1943. (Courtesy U.S. Navy.)

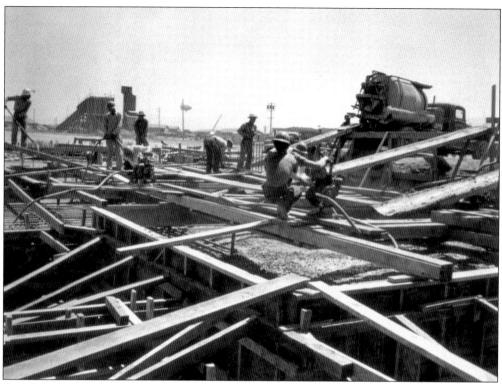

On May 10, 1943, concrete was poured to form the base of one of the door towers of Hangar No. 3. (Courtesy U.S. Navy.)

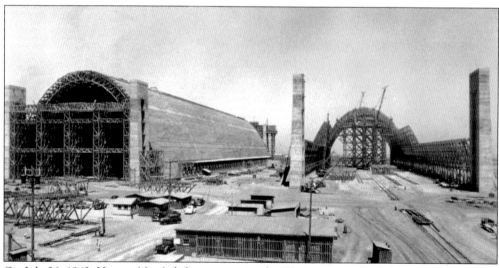

On July 26, 1943, Hangar No. 2, left, was passing the 75 percent mark while Hangar No. 3 was just reaching 25 percent of completion. This view looks toward the San Francisco Bay from the south. (Courtesy U.S. Navy.)

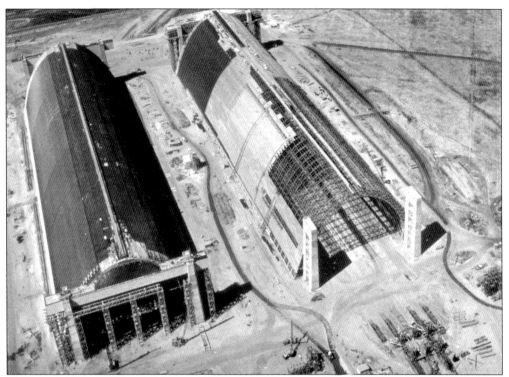

Looking north a few months later, Hangar No. 2, left, is nearly complete and Hangar No. 3 is progressing nicely. Door tracks are in place at both ends of Hangar No. 2, while the north end of Hangar No. 3 is being worked on.

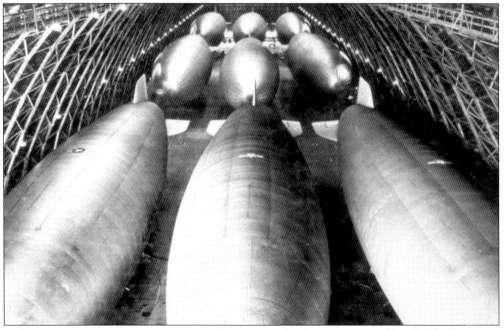

In late 1943, nine blimps were inflated in one of the hangars at Moffett Field. (Courtesy U.S. Navy.)

The hydrogen plant, pictured here on May 10, 1943, was constructed next to Building No. 2, facing Bushnell Street. Hydrogen was piped into Building No. 2 to fill free balloons that were used to train lighter-than-air pilots. (Courtesy U.S. Navy.)

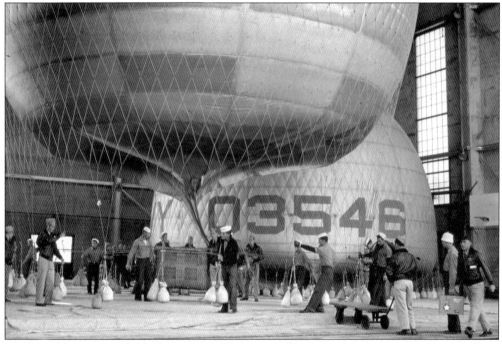

Inside Building No. 2, the balloons were filled. Neutral buoyancy was maintained by attaching sandbags to the balloon net. Sailors then walked the balloon out to the field.

A crowd of sailors would walk the balloon to the airfield where the basket was connected to the netting, and off the intrepid aviators would sail. Reducing buoyancy enabled the balloon pilot to land. Building No. 2 is seen on the left and NACA's flight operations, now Building No. 210, is seen on the right. (Courtesy U.S. Navy.)

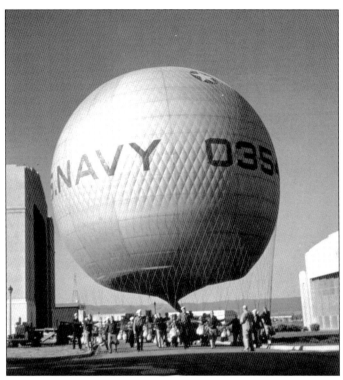

Before launching, the homing pigeon carrier was installed in the balloon's load ring. Note the instrument panel behind the second sailor's hat. (Courtesy U.S. Navy.)

In the basket to the right, Lt. (junior grade) George N. Steelman, holding a pigeon, was Moffett Field's free balloon officer and veteran navy balloon expert. (Courtesy U.S. Navy.)

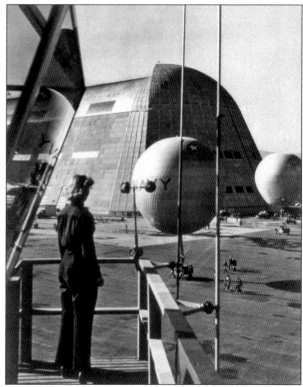

Free balloons are walked past Hangar No. 1 and out to the field, as seen from the temporary control tower. This tower was located near today's airfield fire station, north of Hangar No. 1. (Courtesy U.S. Navy.)

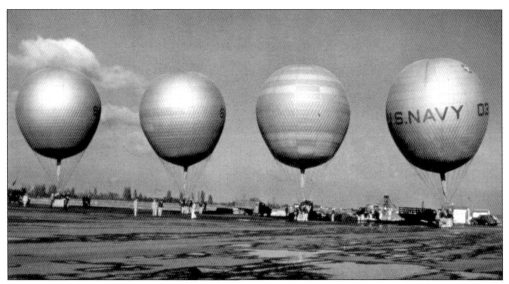

Four free balloons are about to launch in the spring of 1944 after a Bay Area rainstorm has passed through the area. (Courtesy U.S. Navy.)

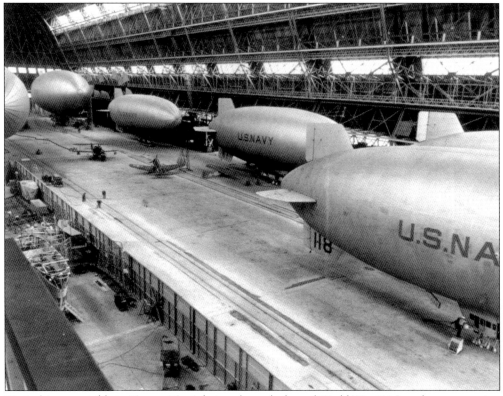

Six L-ships are visible in Hangar No. 1 during the early days of World War II. Note the construction area to the lower left where an L-ship gondola is being prepared. Each L-ship is 149 feet long, has a 123,000 cubic foot gas volume, and can cruise for 520 nautical miles at 40 knots per hour. Aircraft on the hangar floor include a Grumman J2F Duck, a Douglas SBD Dauntless, and a derivative of Piper's Cub. (Courtesy U.S. Navy.)

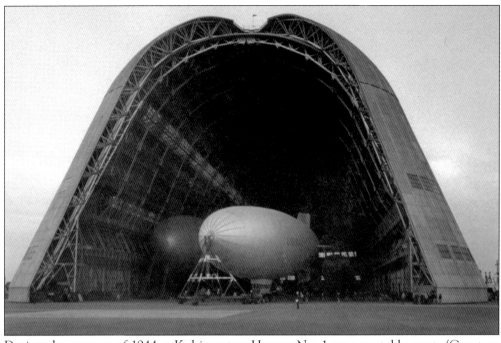

During the summer of 1944, a K-ship enters Hangar No. 1 on a portable mast. (Courtesy U.S. Navy.)

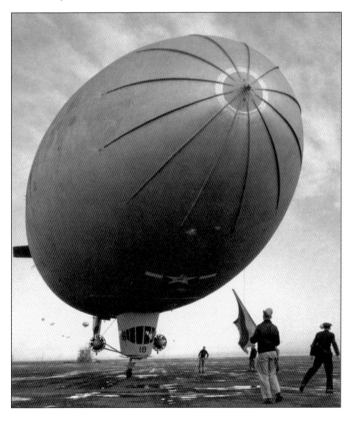

An L-ship departs using the taxi method where the blimp accelerates on the ground before lifting off. Notice the six other blimps in the flight pattern to the rear. (Courtesy U.S. Navy.)

This is a formation of 10 Moffett Field–based L-ships over the south bay at 600 feet. (Courtesy U.S. Navy.)

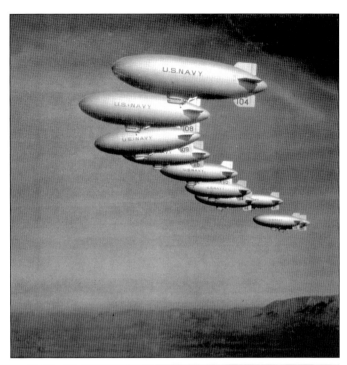

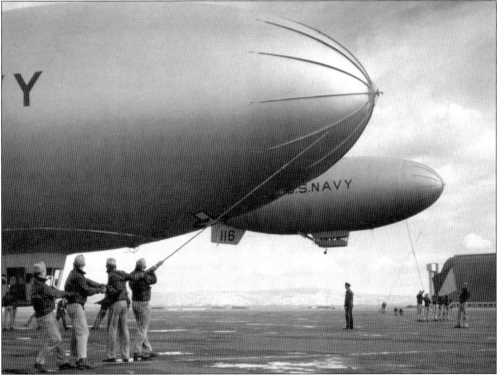

Handling the K-ships upon landing required a lot of muscle and long lines to keep the blimps under control until they could be moored, or crews changed for the next flight. (Courtesy U.S. Navy.)

Enlisted men undergoing training to become lighter-than-air crewmembers were instructed how to use carrier pigeons to send emergency messages. (Courtesy U.S. Navy.)

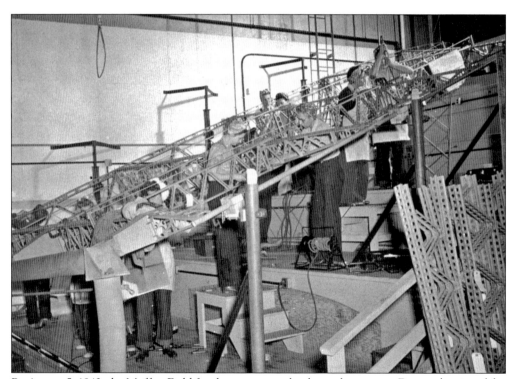

By August 5, 1943, the Moffett Field fin shop was completely run by women. Due to the size of the fins, they were fitted into a jig and constructed at a 45-degree angle, with platforms of increasing height to allow more than a dozen women to work on a fin at one time. (Courtesy U.S. Navy.)

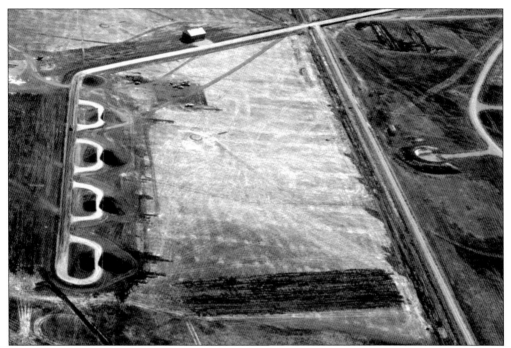

This aerial view of Moffett Field's magazines and the access road looks south on September 19, 1943. Four 25-by-20-foot high explosive storage magazines line the road along with a 10-by-14-foot bunker at the bend. A 40-by-60-foot inert storage building sits at the top of the photograph. The airstrip and Hangars No. 2 and No. 3 are out of the photograph to the right. Stolte Incorporated built the magazines. (Courtesy U.S. Navy.)

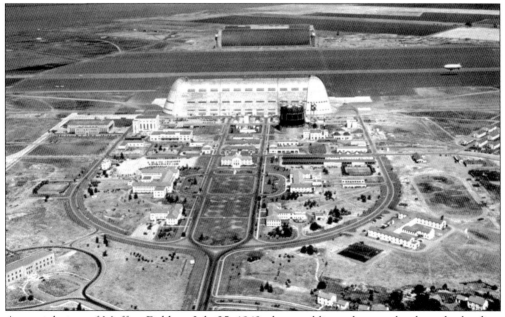

An aerial view of Moffett Field on July 25, 1943, shows a blimp about to land on the landing strip, and in the lower left corner, the nearly completed NACA administration building. Officer's housing is situated in the lower right corner. (Courtesy U.S. Navy.)

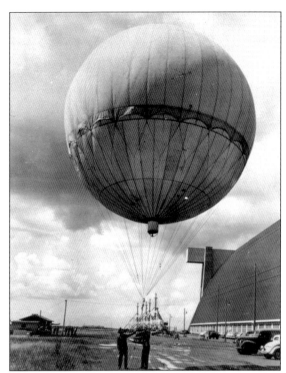

During the closing days of World War II, the Japanese conducted the Fugo offensive, sending hundreds, if not thousands, of incendiary-laden balloons into the jet stream with the intention that they would deflate over forests in the Pacific Northwest, ignite, burn down timber, and cause panic among civilians. An Army P-38 shot down this Fugo balloon, which landed near Alturas, California. The balloon was brought to Moffett Field for examination, and is seen after inflation, with helium on the eastern side of Hangar No. 3 on May 24, 1945. (Courtesy U.S. Navy.)

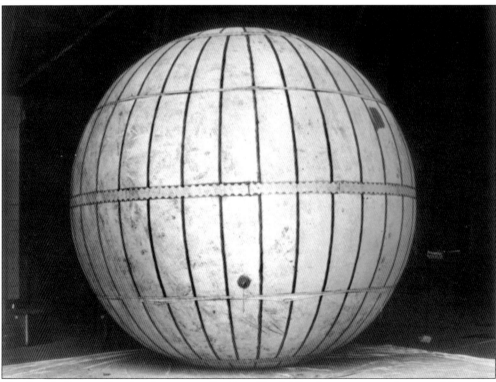

The Fugo balloon inflated with air sits in Building No. 2. The Fugo campaign began in November 1944 and lasted through the beginning of May 1945. (Courtesy U.S. Navy.)

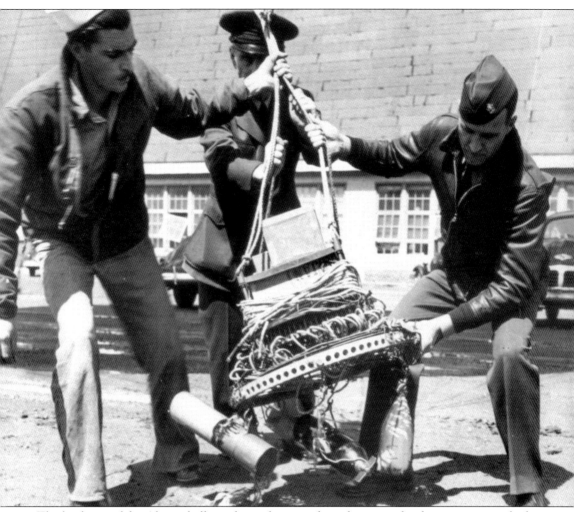

The load ring of the Alturas balloon shows the incendiary devices and radio transmitter, which sent tones denoting when sandbags were dropped to maintain altitude. Each Fugo balloon traveled at 30,000 feet and took about 80 hours to cross the Pacific. (Courtesy U.S. Navy.)

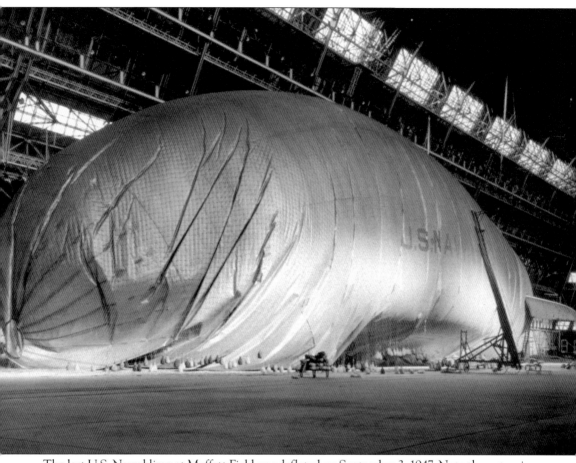

The last U.S. Navy blimp at Moffett Field was deflated on September 3, 1947. Note the extension ladder to the right, used to service the blimps, and the fins that are still attached as the gasbag is deflated. (Courtesy U.S. Navy.)

Three

NACA COMES TO MOFFETT FIELD

Twelve years after the Wright Brothers took to the skies over Kitty Hawk, North Carolina, Congress authorized the National Advisory Committee for Aeronautics (NACA) as an independent government agency. Joseph Sweetman Ames, Ph.D. (1864–1943) was an accomplished professor of physics at Johns Hopkins University and its president from 1929 to 1935. Ames was one of the seven founding members of NACA and the namesake of NACA's Ames Aeronautical Laboratory, now NASA Ames Research Center.

NACA broke ground for the Ames Aeronautical Laboratory on December 20, 1939, on property adjacent to Naval Air Station Moffett Field. Ames would be home to a series of wind tunnels and other aeronautical research assets that would put America at the forefront of aviation technology during the war years. After the war, this position of leadership would be expanded into the forthcoming science of aerospace.

In less than one year, the flight research facility, now Building No. 210, was far enough along to accept the first research aircraft, a North American 0-47A observation aircraft, which arrived on October 14, 1940. In the interim, work was progressing on construction of the 16-foot wind tunnel, a pair of 7-by-10-foot wind tunnels, and the massive 40-by-80-foot wind tunnel.

World War II was many terrible things to millions of people, however, the face of modern warfare advanced the state-of-the-art in aeronautics exponentially. For the first time, bombers were attacking the enemy, routinely flying at altitudes in excess of 25,000 feet. These bombers, escorted by fighters, all encountered icing while flying through weather and at high altitude. Icing research in progress at NACA's Langley Aeronautical Laboratory was brought to Ames. Here thermal deicing techniques were demonstrated, and the lessons learned were disseminated to the aircraft industry, much of which was located on the West Coast.

The 16-foot wind tunnel was ready for business in 1941 and was quickly put to use solving the problem of compressibility. On October 1, 1940, the Vought F4U-1 was the first navy fighter to exceed 400 miles per hour in level flight, and in dives, many other fighters were approaching the speed of sound. Nearing the speed of sound, the aerodynamic shockwave over an aircraft's control surfaces became too great for the pilot to overcome. The 16-foot wind tunnel could produce wind speeds of 680 mph (Mach 0.9), duplicating the compressibility effect. Lessons

learned from these studies were immediately applied to Lockheed's P-38 Lightning and Republic's P-47 Thunderbolt.

Aside from testing airflow over new aircraft designs, Ames's wind tunnel facilities were used to improve and modify existing aircraft. North American Aviation's P-51 Mustang, which would become the Allies' premier air-superiority fighter of World War II, suffered from some teething troubles in its early days. The Mustang featured an in-line, 12-cylinder, water-cooled engine. Heat from the engine was exchanged through a radiator and oil cooler that were buried in the fuselage, aft of the wing. Air to cool the radiators was inducted through a belly scoop, which in the early P-51A and P-51B models was "rumbling" at speeds in excess of 350 mph. Apparently this duct rumble was quite disconcerting and loud enough that pilots thought their aircraft was about to break apart.

To address the duct-rumble issue, a P-51B was flown to Ames, its outer wing panels were removed, and it was installed in the 16-foot wind tunnel for tests. As airflow through the belly scoop was monitored, Ames aerodynamicists reconfigured the inlet to smooth out air flow through the duct. The newly designed duct's parameters were given to North American Aviation, and the aircraft's design was subsequently modified.

The 40-by-80-foot wind tunnel came online in June 1944 as a number of late-war aircraft designs were coming to fruition. The 40-by-80-foot tunnel enabled a full-scale aircraft to be tested. Douglas sent its A-26 Invader to the tunnel, while Grumman's F7F Tigercat, and General Motors' P-75 Eagle were tested, to name only three.

With the end of the war, came the construction of more sophisticated wind tunnels to handle advances in technology, including swept wings, jet propulsion, and supersonic flight.

Groundbreaking for the first NACA structure took place on December 20, 1939. The gentleman in the trench coat to the right is Russell Robinson, who supervised construction on behalf of NACA headquarters. (NASA Ames History Office.)

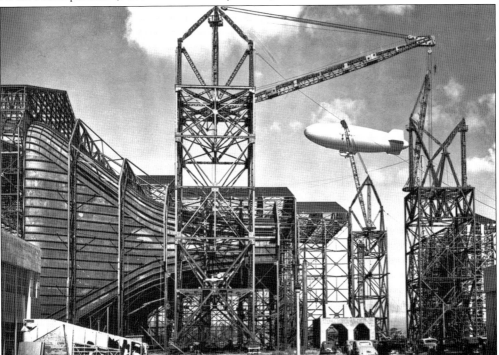

By June 1943, construction of the 40-by-80-foot wind tunnel was progressing under the watchful eyes of navy blimps. (NASA Ames History Office.)

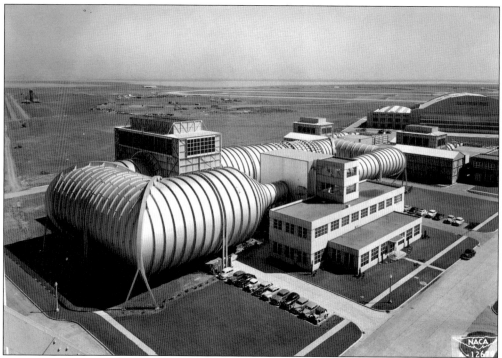

The 16-foot, high-speed wind tunnel began operations in 1941 and was capable of speeds of Mach 0.9, or 680 mph. This tunnel was used extensively for simulating compressibility, where the supersonic shockwave of an aircraft flying near the speed of sound is too great for the pilot to overcome, essentially freezing an aircraft's control surfaces. Note the *Macon* mooring mast to the left of the tunnel and the remnants of the north mooring circle above the tunnel. (Courtesy NASA.)

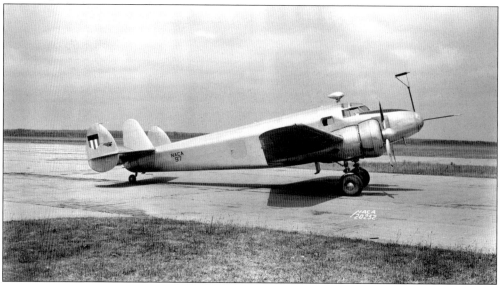

This Lockheed 12A was one of the first research aircraft transferred from NACA's Langley Aeronautical Laboratory and used for early icing research. This aircraft used heated wings to defeat ice buildup. (Courtesy NASA.)

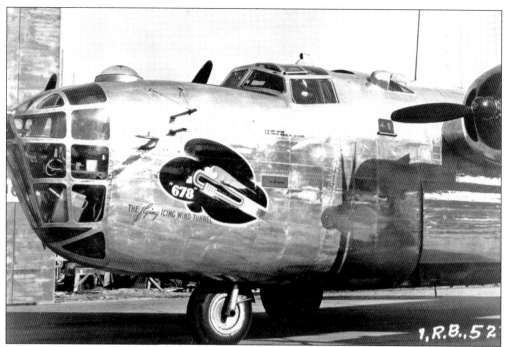

Consolidated XB-24F serial No. 41-11678 was fitted with a thermal deicing system at Ames. The aircraft is seen later in its career wearing the title *The Flying Icing Wind Tunnel*. (Courtesy NASA.)

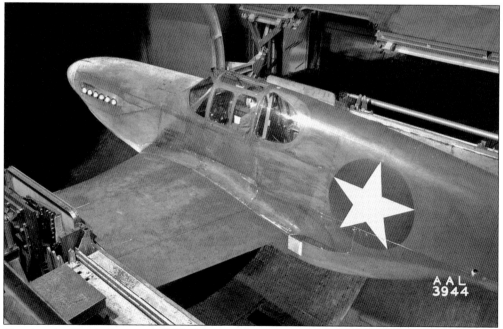

To solve the North American P-51's duct-rumble issue, a full size XP-51B was flown to Ames, its outer wing panels removed, and the fighter installed in the 16-foot wind tunnel. Reportedly a NACA engineer rode in the cockpit during the tests to help determine where the rumble was coming from and when it began and ended. (Courtesy NASA.)

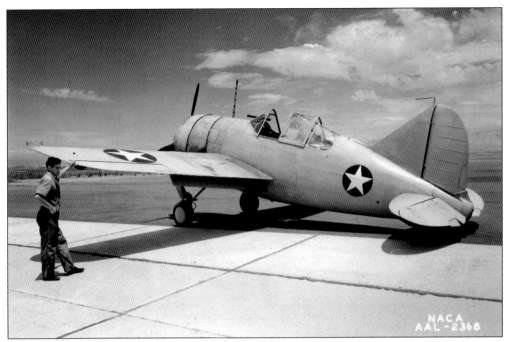

A Brewster F2A-3 Buffalo fighter, Bureau No. 01516, was tested at Ames in 1942 to evaluate its flying characteristics. U.S. Marines in their F2As bravely fought against superior Japanese forces at the Battle of Midway, June 4–7, 1942. After the slaughter of the Buffalos at Midway, the type was pulled from frontline service. (Courtesy NASA.)

Wind tunnel testing often involves using exact scale models to test an aircraft design. Many design variables can be tested inexpensively before a design is committed to production. Here airflow over the wings of a Vought F4U-1 Corsair model was studied in an Ames wind tunnel to determine wing stall. As originally built, the Corsair's left wing stalled before the right, making landings aboard ship difficult until the problem was corrected by adding a stall inducer to the starboard outer wing panel. (Courtesy Veronico collection, NACA.)

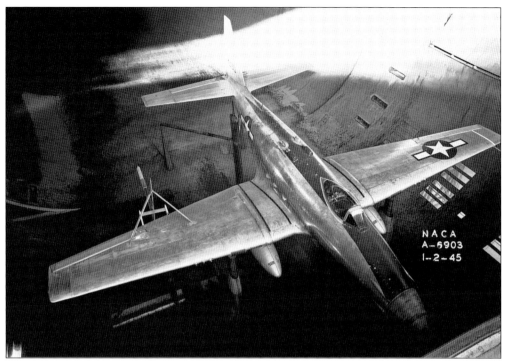

The full size Fisher P-75 Eagle was tested in the Ames 40-by-80-foot wind tunnel. This aircraft is serial No. 44-44550. The first prototype, it was powered by a 2,600 horsepower Allison V-3420-19 that drove contra-rotating propellers to reduce torque. (Courtesy NASA.)

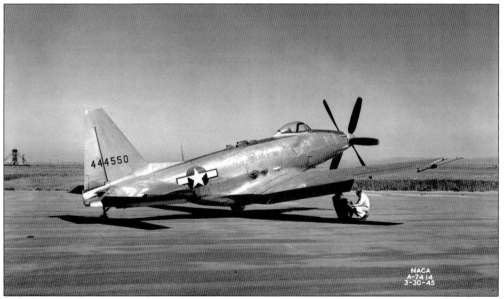

Fisher's P-75, seen here on the Ames ramp, was General Motors' idea of building an air superiority fighter using existing aircraft components (F4U Corsair main landing gear, P-40 Warhawk outer wing panels, and SBD Dauntless tail assembly) married to a new center section, nose, and power plant package. The success of existing fighters, such as the P-51, eliminated the need for the P-75. (Courtesy NASA.)

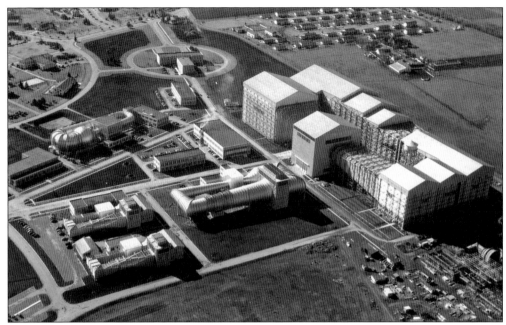

This is an aerial view of Ames Aeronautical Laboratory's wind tunnel complex. From the lower left, two 7-by-10-foot tunnels sit next to the 16-foot high-speed tunnel, with the 40-by-80-foot tunnel to the right. Below and to the right, work has begun on the six-by-six-foot supersonic wind tunnel. Above the twin 7-by-10-foot tunnels is the 12-foot pressure tunnel. Note that trees are starting to mature on the navy side of the base and near the main gate. (Courtesy NASA.)

Ames test pilot Lawrence Clousing is about to board a Lockheed P-80 with seat-pack parachute. Clousing was one of the early Ames pilots that included Bill McAvoy, Jim Nissen, and George Cooper. (Courtesy NASA.)

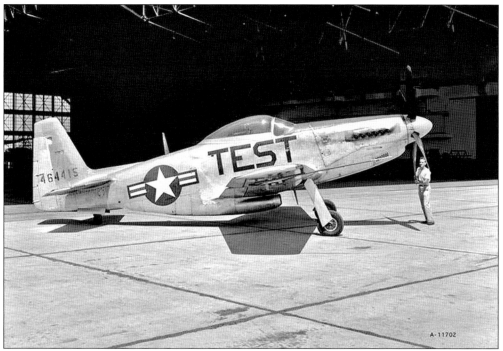

North American's P-51H was the final, light-weight development of the Mustang series of fighters. NACA used a number of Mustangs for the wing flow method of high speed tests. (Courtesy A-11702/NASA.)

The wing flow method involved mounting a test shape on the outer wing panel of an aircraft, in this case a P-51H, flying the aircraft to altitude, then diving to attain high speeds while recording fluid (air) behavior over the model. Here at technician installs recorders in the Mustang's gun bays. (Courtesy NASA.)

A P-51D at Ames is fitted with an instrumented Lockheed P-80 model for high speed tests. (Courtesy NASA.)

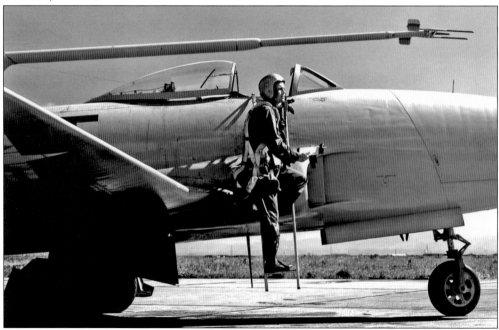

NACA test pilot Ryland S. Carter, pictured with a Lockheed P-80 jet fighter, perished when the P-51H he was flying, serial No. 44-64691, broke up in mid-air on May 17, 1948. While flying at high speeds with a model on the left wing, it separated in flight, with the wreckage coming to rest in a field in Newark, California. The flight testing community remembers the sacrifices pioneering aviators like Carter made to advance aviation science. (Courtesy NASA.)

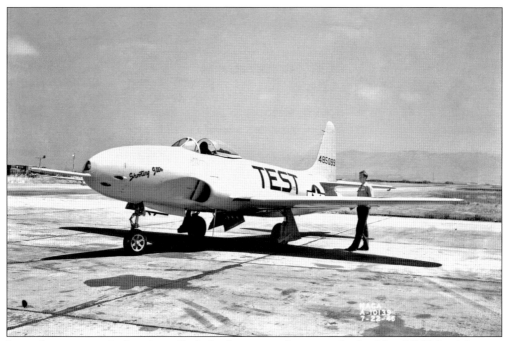

Legendary aeronautical engineer Seth Anderson stands next to the Lockheed P-80A, with a test instrument nose boom. Early P-80s suffered an "aileron buzz" that was corrected by Anderson and his colleagues. (Courtesy NASA.)

North American's F-86 Sabre came to Ames' 40-by-80-foot wind tunnel for investigation of airflow over its outer wing panels and to improve the fighter's stall characteristics. (Courtesy A-15939/NASA.)

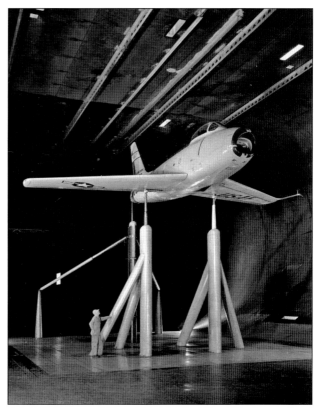

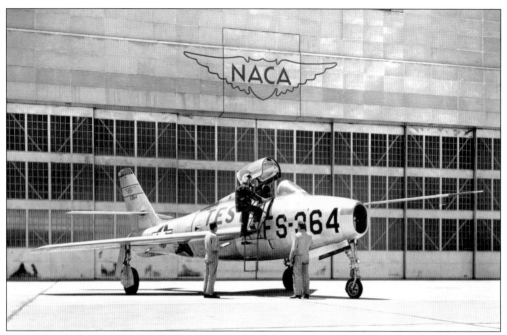

Ames obtained a Republic F-84F Thunderjet for high-performance flight data recording at transonic speeds. Data collected from these flights was used to guide future designers. The aircraft is seen on the ramp in front of NACA's main hangar, now Building No. 211. (Courtesy NASA.)

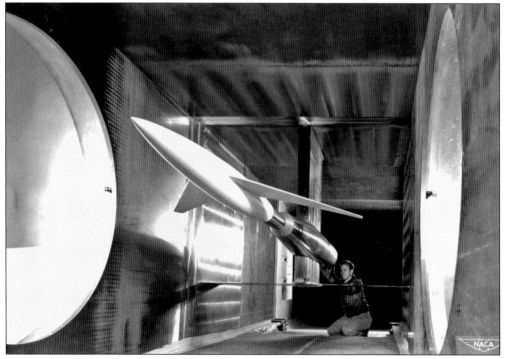

A futuristic aircraft shape is tested in the six-by-six-foot supersonic wind tunnel. This tunnel was used extensively for supersonic engine inlet studies. It was mothballed in the late 1980s. (Courtesy NASA.)

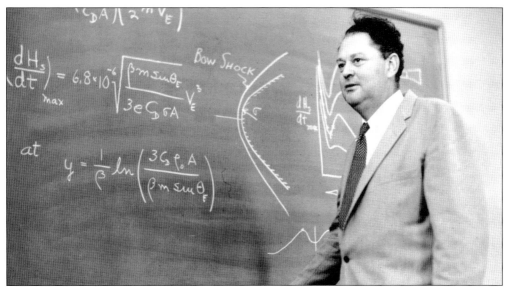

H. Julian Allen developed the "Blunt Body" theory, which reduces friction heating when a vehicle reenters the Earth's atmosphere. Allen's theory was quickly adopted to ballistic missiles and incorporated into the design of the Mercury, Gemini, and Apollo space capsule heat shields. He later served as center director of NASA Ames from 1965 to 1969. (Courtesy NASA.)

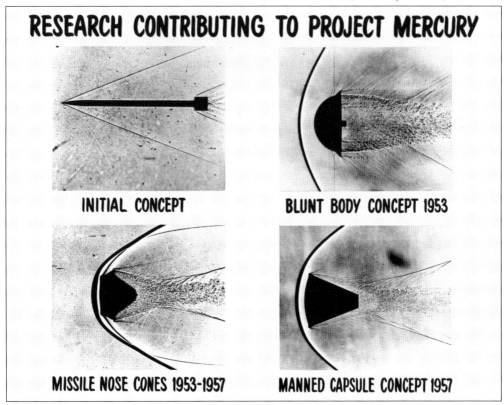

Visual representation of Allen's Blunt Body theory shows the behavior of the supersonic shockwave as represented by the black line ahead of the shape. (Courtesy NASA.)

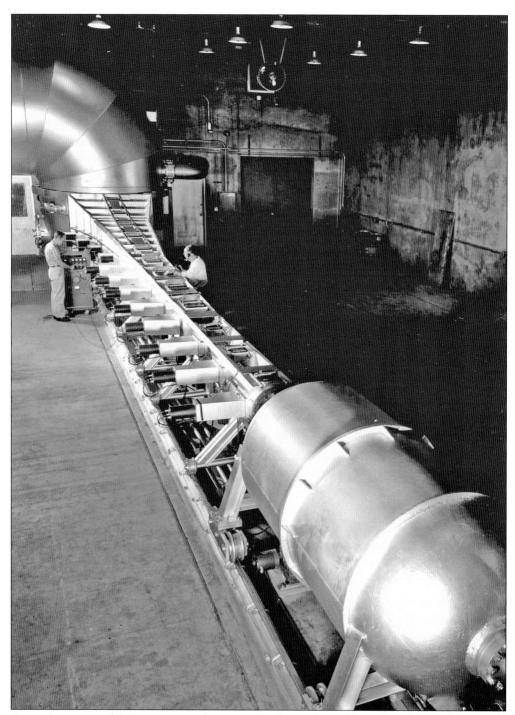

Ames Aeronautical Laboratory was home to the Atmospheric Entry Simulator, which could simulate air densities to replicate reentry as a vehicle descends in altitude. A gun fired a model at full speed to determine if a vehicle design could survive reentry to Earth's atmosphere. (Courtesy NASA.)

Four

NAVY AND AIR GUARD OPERATIONS

Leaving World War II behind and looking forward, the U.S. Navy faced a tremendous time of change. The U.S. Air Force, which had become independent from the army in 1947, believed there was no need for naval aircraft, capital ships, or expensive aircraft carriers for that matter. In Congress, the air force worked to obtain as much funding as possible to upgrade its strategic bomber force to combat the Soviet threat.

While the services struggled in Washington, D.C., Moffett Field transitioned from lighter-than-air training to becoming a hub for the Military Air Transport Service. The air station's massive hangars went from blimps to four-engine Douglas R5D Skymasters and later R6D Liftmasters serving VR-5 and the navy's cargo and personnel transportation needs throughout the Pacific. When war broke out in Korea, Moffett Field added fighters to its fleet of aircraft, with the F9F Panther jets of VF-191 being the first all-jet squadron to be stationed at the base. In 1949, Composite Squadron 3 called Moffett Field home when ashore. The squadron operated Douglas Skyraiders, McDonnell Banshees, and Vought F4U-5N night fighter Corsairs.

By 1962, patrol squadrons began moving into Moffett Field, beginning the air station's 30-year association with the Lockheed P-3 Orion anti-submarine warfare patrol aircraft. The P-3 was adopted from the commercial Electra airliner and made an outstanding sub hunter.

As Vietnam wound down in 1973, the Pacific Fleet chose Moffett Field as its primary anti-submarine warfare training base and home to its patrol squadrons flying the P-3 Orion. The four-engine turboprop-powered sub hunters could be seen in the South Bay skies, returning from missions or practicing take offs and landings.

In the budget-tightening years of the late 1980s and early 1990s, Moffett Field was targeted as part of the Department of Defense's base realignment and closure effort. The base was on the 1990 list, however, political pressure stayed the closure by one year. As the patrol squadrons stood down, the U.S Navy prepared to leave Moffett Field after more than 60 years. Most of the active navy was gone by the end of 1991, with reserve units occupying the field until 1999. The closure ceremony was held on July 1, 1994, and the keys to the base were turned over to NASA, who would operate the former air station as Moffett Federal Airfield.

Although the U.S. Navy pulled out, the Air National Guard continued its operations at Moffett Federal Airfield. The 129th Rescue Wing traces its lineage back to April 1955, when the unit was formed at the Hayward Airport as the California Air National Guard's 129th Air Resupply Group. In 1975, the 129th fell under the command of the U.S. Air Force, and its mission changed to combat search and rescue. In 1984, the unit completed its move to Moffett Field, and in 1991, began operating HH-60G Pave Hawk helicopters in concert with various models of the C-130 Hercules transport.

Since the beginning of this decade, the 129th has been in the thick of the action, both home and abroad. During the September 11, 2001, attacks on the United States, the "Citizen Airmen" of the 129th had already deployed for combat search and rescue as part of Operation Southern Watch in Iraq. Those members of the 129th who had not deployed overseas were asked to secure Mineta San Jose Airport until effective civilian law enforcement could perform passenger screening and other security duties.

In March 2002, the unit went overseas to participate in Operation Northern Watch, followed by deployment to Oman for Operation Enduring Freedom. On the home front, 2005's Hurricane Katrina saw the unit deployed as one of the first responding units, providing rescue and medical aid to citizens in and around New Orleans, Louisiana. During the hurricane relief effort, 212 people were aided by 129th helicopter and pararescue personnel, and untold others were evacuated in the unit's MC-130 transports.

As of November 2005, the 129th is credited with saving the lives of 550 people. The 550th person was lifted off a cruise ship by a 129th HH-60 helicopter and flown to Stanford Hospital in Palo Alto, California. As "Citizen Airmen," the men and women of the 129th selflessly serve our nation and community, and are a big part of Moffett Field and its history.

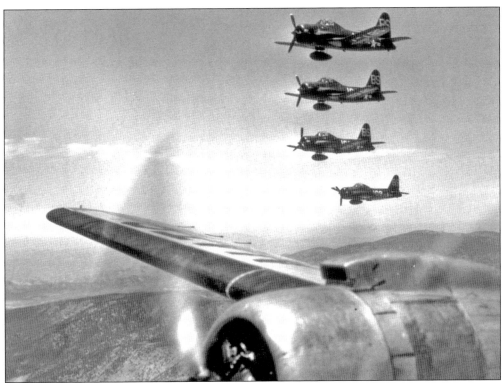

The prototype Ryan Fireball was first flown in June 1944, at a time when the navy was experimenting with jet propulsion. The Fireball was fitted with a Wright R-1820 radial engine and a 1,600-pound static thrust General Electric J31-GE jet buried in the fuselage. Sixty-six were built, and they were capable of flying on jet power with the R-1820 engine off and the propeller feathered as shown here. These four Fireballs are following a Douglas R4D down the San Joaquin Valley to NAS North Island. (Courtesy U.S. Navy.)

In March 1952, Military Air Transport Service R6D-1, Bureau No. 128427, is on final approach for Moffett Field. In the 1950s, Moffett Field was the West Coast hub for the navy's transport squadrons. (Courtesy William T. Larkins.)

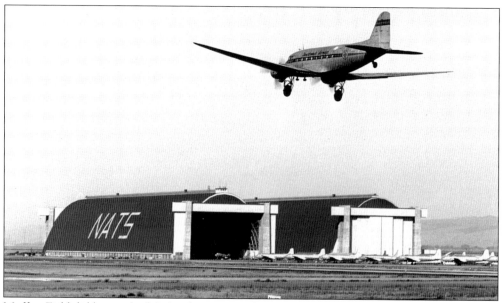

Moffett Field did have scheduled airline service from March 10, 1947, to January 31, 1949, while San Jose Municipal Airport was upgraded to handle airliner-type aircraft. Southwest Airways operated two daily flights into Moffett Field with 21-passenger Douglas DC-3s. Notice the Naval Air Transport Service markings on Hangar No. 2 and the R5D transports on the ramp. (Courtesy William T. Larkins.)

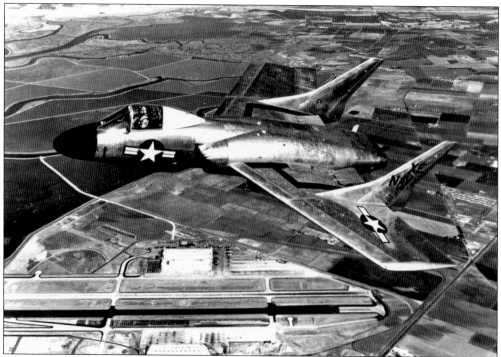

The tailless F7U Cutlass was an aircraft design that was ahead of its time. The plane had a fantastic roll rate, featured afterburning engines, and yet was underpowered. This aircraft was operated by VX-5 from Moffett Field. (Courtesy U.S. Navy.)

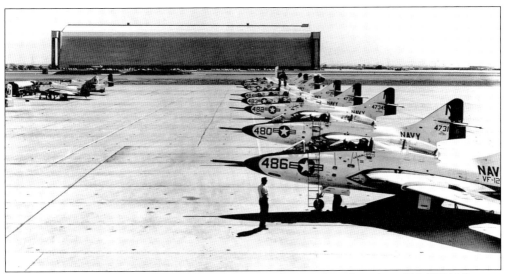

In the summer of 1960, Grumman F9F-8T Cougars from Fighter Squadron 124 (VF-124) came ashore at Moffett Field. VF-124 served as a transition training squadron for pilots moving up to swept-wing fighters. On April 11, 1958, VF-124 became operational at Moffett Field and moved south to NAS Miramar, north of San Diego, three years later. (Courtesy U.S. Navy.)

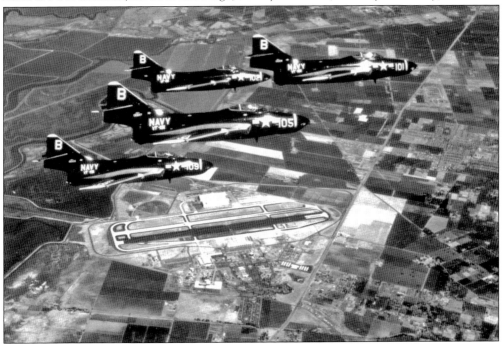

VF-191 *Satan's Kittens* are flying swept-wing Grumman F9F Cougars over Moffett Field after the Korean War. When war with the North Koreans broke out in June 1950, the U.S. Navy Blue Angels were recalled to the fleet. They formed the nucleus of VF-191, as the squadron transitioned from piston-powered F8F Bearcats to F9F Panther jets in preparation for Korean service. The squadron formed at Moffett Field, becoming the air station's first all-jet powered squadron. The VF-191 then crossed the Pacific for combat operations aboard the USS *Princeton* (CV-37). (Courtesy U.S. Navy.)

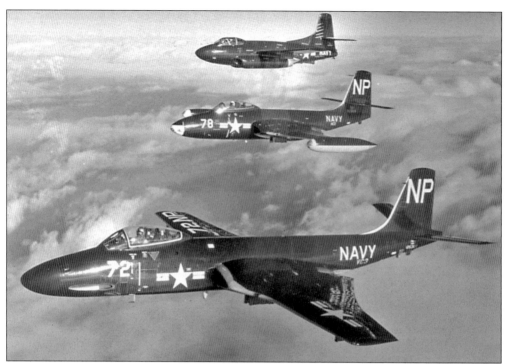

In the mid-1950s, Moffett Field was home to Composite Squadron 3 (VC-3). Here three of the squadron's aircraft fly off the California coast. Lower is the then-new McDonnell F2H-3 Banshee, F2H-2 in the center, with a McDonnell F3D Skynight, the navy's first jet-powered night fighter, on the outside of the formation. (Courtesy U.S. Navy.)

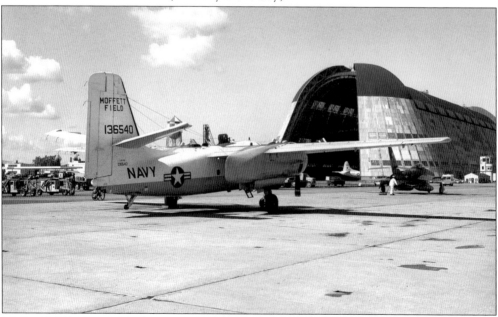

Moffett Field had its own utility transport, a US-2B, Bureau No. 136540. The aircraft is a converted S2F-1 antisubmarine patrol aircraft. Note that Hangar No. 1 is now being used for P-3 maintenance. This photograph was probably taken in the late 1960s. (Courtesy U.S. Navy.)

Convair built two XFY-1 Pogos for the navy as single-seat VTOL fighters. The plane was 31-feet long, with a 26-foot wide Delta-shaped wing, and powered by a 5,500 shaft horsepower YT40-A-14, two T-38 coupled engines, driving counter-rotating, Curtiss-Wright, three-blade propellers. Tethered tests of the Pogo were accomplished inside Hangar No. 1 during April 1954. Later in 1954, the aircraft flew untethered. At the time, the aircraft was considered to be underpowered and difficult to control at low speeds. (Courtesy U.S. Navy.)

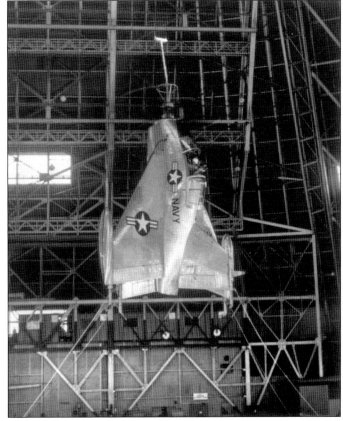

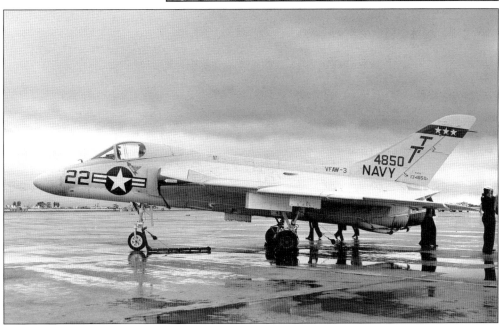

Douglas F4D-1 Skyray, Bureau No. 134850, from Fighter Squadron, All-Weather Three (VFAW-3) is at Moffett Field in the late 1950s. (Courtesy William T. Larkins.)

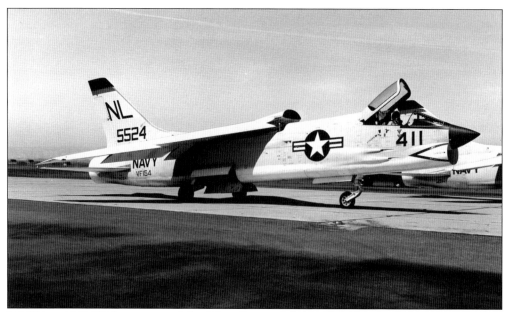

VF-154 and VFAW-3 were two of the West Coast's first squadrons to receive the Vought F8U Crusader. This aircraft, Bureau No. 145524, is an F8U-1E, a limited, all-weather interceptor fitted with a nose radar scanner. It is seen on the Moffett Field transient line on May 16, 1959. (Courtesy William T. Larkins.)

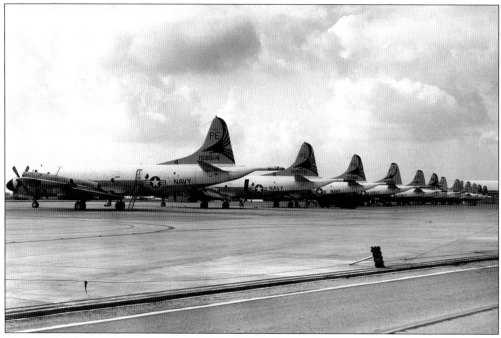

Moffett Field became home to the U.S. Pacific Fleet's patrol wing commander in 1973, making the air station the west coast's largest antisubmarine warfare base. A wide variety of U.S. Navy and international P-3 squadrons could be seen on the base at any one time. This lineup of P-3s includes aircraft from patrol squadrons VP-19 (PE tail code), VP-6 (PC), and VP-22 (QA). (Courtesy U.S. Navy.)

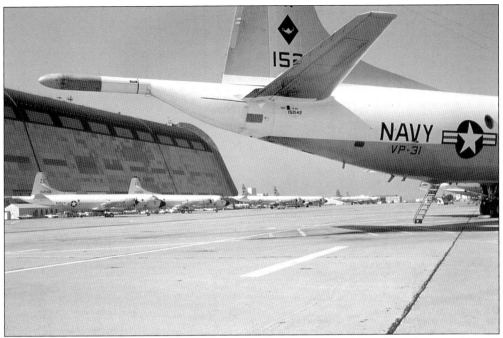

Two VP-17 P-3s from their home port of NAS Barbers Point, Hawaii, are framed against Hangar No. 1 by a Moffett-based VP-31 P-3A. Patrol Squadron 31 was the primary West Coast P-3 training outfit, while VP-17 saw extensive service during the Vietnam War. (Courtesy U.S. Navy.)

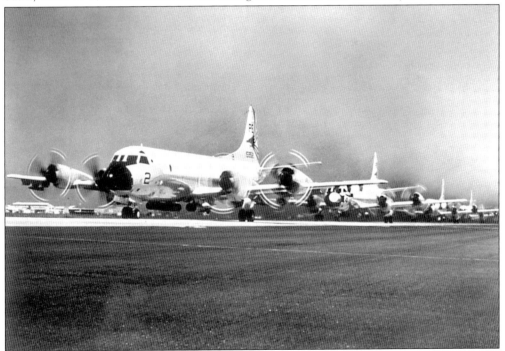

Moffett Field–based Patrol Squadron 19, "Big Red," P-3 Orions taxi out with mines fitted to the external bomb racks. VP-19 began operations at Moffett Field on September 1, 1963, and was disestablished on August 31, 1991. (Courtesy U.S. Navy.)

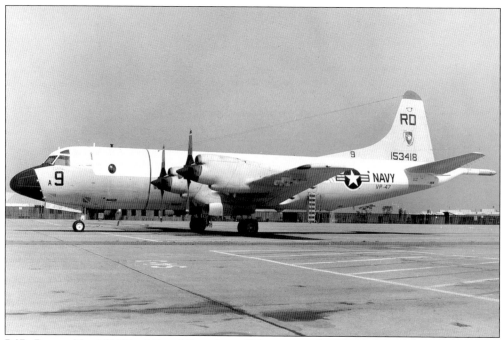

P-3B, Bureau No. 153418, of Patrol Squadron 47, known as the "Golden Swordsmen" (tail code RD), parked on the far side of the field. Note the crew-boarding ladder suspended from the rear entry hatch. VP-47 saw extensive service in Vietnam. (Courtesy U.S. Navy.)

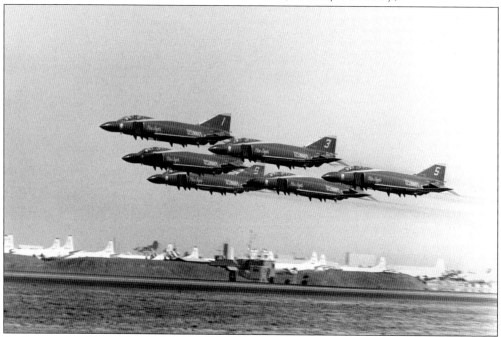

Airshows at Naval Air Station Moffett Field were always a treat for the public. The station was a favorite show stop for the U.S. Navy Blue Angels, seen flying McDonnell Douglas F-4 Phantom IIs. The aircraft are passing low over the field in the Delta Diamond formation in the summer of 1969. (Courtesy William T. Larkins.)

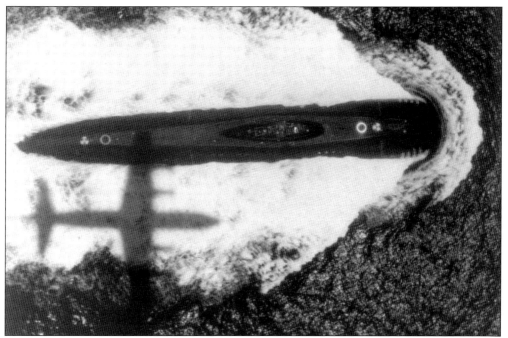

Moffett Field–based sub hunters are here doing what they did best—shadowing Soviet submarines, this one off the California coast, c. 1979. (Courtesy U.S. Navy.)

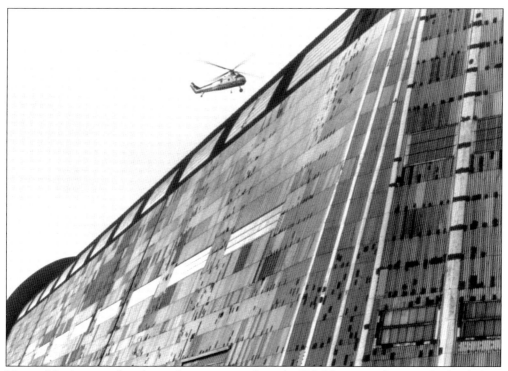

Hangar No. 1 received its share of maintenance from the U.S. Navy over the years. In April 1983, a contractor's helicopter was used to aid workers in repairing the roof. (Courtesy U.S. Navy.)

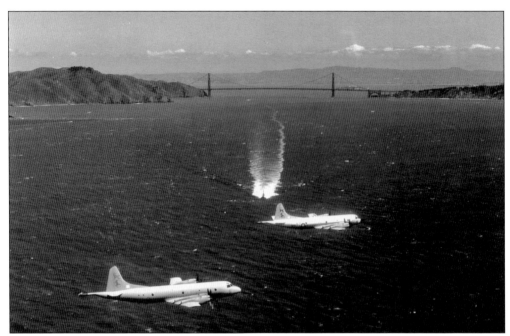

Nice navy publicity photograph from the late 1980s with a P-3B leading a new P-3C over a U.S. Navy submarine departing the Golden Gate. Both aircraft are from Moffett Field's Patrol Squadron 19. (Courtesy U.S. Navy.)

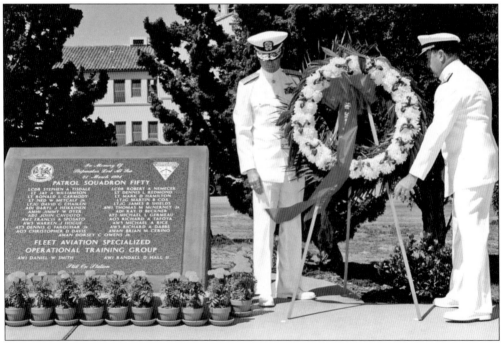

Patrol Squadron 50, the "Blue Dragons," lost 27 crewmembers on March 21, 1991, when P-3C Bureau No. 158930 and P-3C Bureau No. 159325 collided in midair while patrolling over the Pacific off the coast of San Diego, California. Services for the crews were held at Moffett Field and Arlington National Cemetery. (Courtesy Moffett Field Museum.)

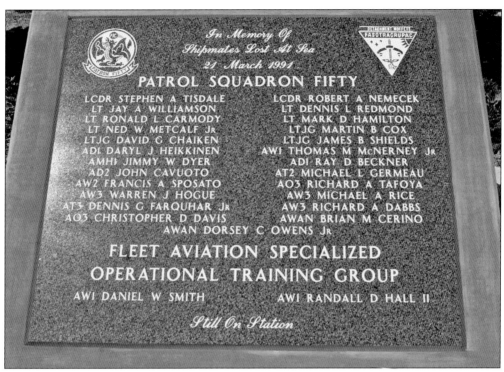

In Memory Of
Shipmates Lost At Sea
21 March 1991

PATROL SQUADRON FIFTY

LCDR STEPHEN A TISDALE	LCDR ROBERT A NEMECEK
LT JAY A WILLIAMSON	LT DENNIS L REDMOND
LT RONALD L CARMODY	LT MARK D HAMILTON
LT NED W METCALF Jr	LTJG MARTIN B COX
LTJG DAVID G CHAIKEN	LTJG JAMES B SHIELDS
ADL DARYL J HEIKKINEN	AWI THOMAS M McNERNEY Jr
AMHI JIMMY W DYER	ADI RAY D BECKNER
AD2 JOHN CAVUOTO	AT2 MICHAEL L GERMEAU
AW2 FRANCIS A SPOSATO	AO3 RICHARD A TAFOYA
AW3 WARREN J HOGUE	AW3 MICHAEL A RICE
AT3 DENNIS G FARQUHAR Jr	AW3 RICHARD A DABBS
AO3 CHRISTOPHER D DAVIS	AWAN BRIAN M CERINO
AWAN DORSEY C OWENS Jr	

FLEET AVIATION SPECIALIZED
OPERATIONAL TRAINING GROUP

AWI DANIEL W SMITH	AWI RANDALL D HALL II

Still On Station

VP-50 placed this monument to its fallen comrades outside the Officers' Club (Building No. 3) in a garden area near South Akron Road and McCord Avenue. The marble monument lists the names of all 27 crewmembers "still on station." (Courtesy Moffett Field Museum collection)

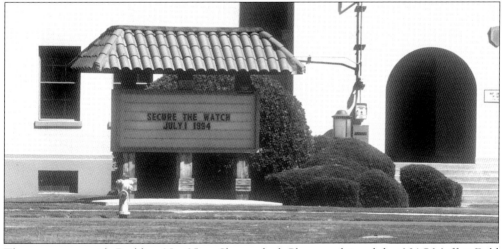

SECURE THE WATCH
JULY 1 1994

The marquee outside Building No. 25 on Shenandoah Plaza proclaimed that NAS Moffett Field was officially disestablished on July 1, 1994. (Courtesy Wayne McPherson Gomes.)

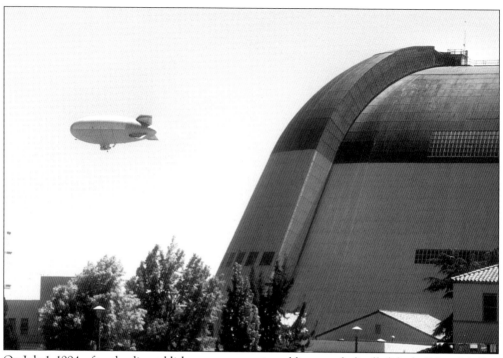

On July 1, 1994, after the disestablishment ceremonies, a blimp symbolically lifted off from Moffett Field. (Courtesy Wayne McPherson Gomes.)

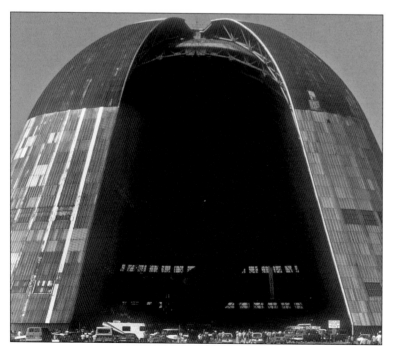

Rarely are there so many cars and people in front of Hangar No. 1 as occurred during the July 1, 1994, disestablishment proceedings. The people and vehicles lend scale to the massive doors of Hangar No. 1. (Courtesy Wayne McPherson Gomes.)

The ceremonial cannons at the west end of Shenandoah Plaza rendered a 21-gun salute to close out the navy's more than 60 year history at Moffett Field. (Courtesy Wayne McPherson Gomes.)

A Moffett Field sailor rings the bell in honor of those who had fallen during service to this nation. (Courtesy Wayne McPherson Gomes.)

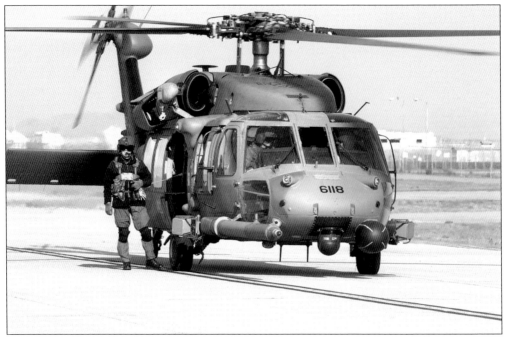

"That Others May Live" is the motto of the 129th Rescue Wing, based at Moffett Federal Airfield. The unit's primary mission is combat search and rescue, however, during peacetime, they are dedicated to saving lives from the Pacific Ocean to the Sierra Nevada Mountains. The wing operates the MC-130P Combat Shadow rescue tanker and the HH-60G Pave Hawk helicopter. (Courtesy 129th RQW.)

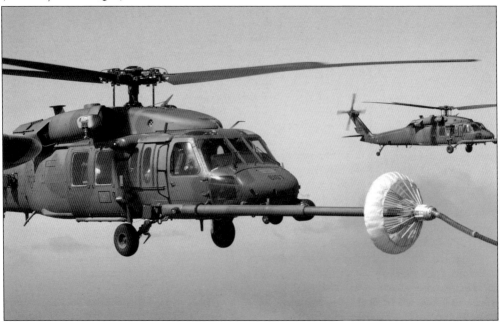

Refueling from the MC-130, the Pave Hawk helicopters can travel long distances out to sea. During the Hurricane Katrina relief efforts, the 129th was part of the first responders to the disaster, and the unit is credited with 212 lives saved. (Courtesy 129th RQW.)

Five

NASA Ames Research Center

Hidden behind the gates of Moffett Field, the NASA Ames Research Center has made tremendous contributions to a wide range of sciences and technologies. In 1958, the National Advisory Committee for Aeronautics became an independent federal agency, changing its name to the National Aeronautics and Space Administration. The new name positioned the agency to do battle in the space race with the Soviets and to provide greater aeronautical resources to a changing industry.

For the majority of the 1950s, it was believed that the U.S. military would do battle with the Soviet Union, streaking past their radar and defeating antiaircraft missiles with supersonic speed alone. To this end, the U.S. military specified that its aircraft be primarily supersonic—the century series of fighters (F-100, F-101, F-104, F-105, and F-105) and the B-58 Hustler bomber for example. Although the cold war continued, the face of warfare changed during Vietnam. Operations were now slower and in the transonic envelope of flight. Helicopters were the major mode of transportation, and air support of troops and interdiction was the name of the game.

To meet the evolving model of military aviation, Ames Research Center's wind tunnels were kept busy, and collaboration was formed with the U.S. Army to further rotorcraft science. Vertical take off and landing (VTOL) studies flourished, and coupled with that, other complementary aviation technologies have followed suit. Human-factors research, airspace safety, and airspace systems have seen tremendous improvements due in great part to the research conducted at Ames.

Few realize the contributions of Ames to the Mercury, Gemini, Apollo, space shuttle, and other space programs. Capsule heat shields were designed and tested, escape systems were validated, and navigation systems were developed for space travel—all at Ames Research Center.

Space biology and the expanding field of astrobiology are two core disciplines at Ames. Astrobiology seeks to determine the origin of life on Earth by seeking life-giving compounds in the solar system. Missions to recover samples from the tails of comets will provide astrobiologists with a glimpse of how these compounds are transported and dispersed among planets. The space shuttle, comet probes, and other craft are protected during reentry by heat shields and materials developed by researchers in the Ames Thermal Protection Systems branch and tested in the ARC Jets. In ARC Jets, the shields meet the heat to determine their survivability during reentry.

The evolution of computers and computer networking has been a big part of Ames and its NASA Advanced Supercomputing Division. During the infancy of the Internet, c. 1995, nearly 95 percent of the West Coast Internet traffic passed through NASA Ames. The evolution of supercomputers at Ames has improved the state-of-the-art physics-based disciplines, including computational fluid dynamics, nanotechnology, turbulence modeling, weather modeling, and networking. In the launch of Space Shuttle Discovery (STS-114), foam debris coming off the external fuel tank and its potential impact on the orbiter were of great concern. Behavior of the foam and its trajectory, in this case past the orbiter, were modeled with supercomputers and the software developed at Ames.

Today the NASA Ames Research Center is a critical part of the NASA mission. Whether training astronauts in the center's Vertical Motion Simulator, improving air travel, or making the next advance in a number of scientific disciplines, NASA Ames is at the forefront of technology.

The Bell X-14 vertical take off and landing (VTOL) aircraft is simulating a landing on the moon. The descent begins from 1,000 feet and is slowed by changing the position of the jet's exhaust. Ames became a leader in VTOL research as the result of testing the X-14A and B, the Ryan VZ-2, VZ-3, and VZ-4, as well as the Bell XV-3. This knowledge base enabled Ames researchers and flight test engineers to make the XV-15 program such a success. (Courtesy A-29688-1/NASA.)

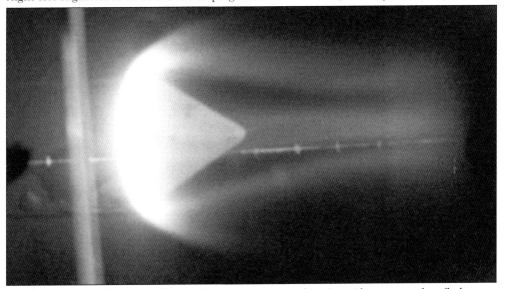

Apollo space capsule reentry thermodynamics were tested in Ames' hypersonic free flight gun. Heat shield materials were also tested in the ARC Jets, part of the center's Thermal Protection Systems development branch. (Courtesy NASA.)

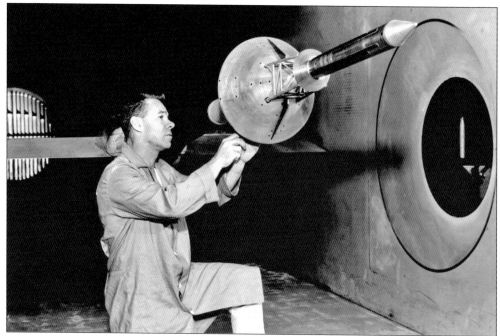

Ames provided a number of its resources for use in the Apollo program, like the Unitary Plan Wind Tunnel. The experiment in the wind tunnel test section is the Apollo Launch Escape System, which used rockets to lift the command capsule off the Saturn V should a problem be detected before orbit. (Courtesy NASA.)

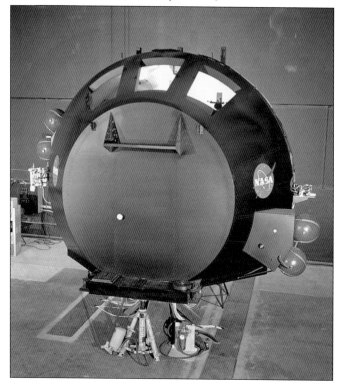

Almost everything in the Apollo program was invented specifically for the mission. That included navigating from one planet to another celestial body. The Apollo navigation simulator was developed at Ames to simulate the mid-course correction required for the journey to the moon. (Courtesy NASA.)

Samples from the Apollo missions were tested at Ames in specially designed glove boxes. Banks of the glove boxes enabled a researcher to pass samples without having to expose them to the laboratory's atmosphere. One of these glove boxes was recently on display in the Ames Exploration Center and during the center's 65th anniversary. (Courtesy NASA.)

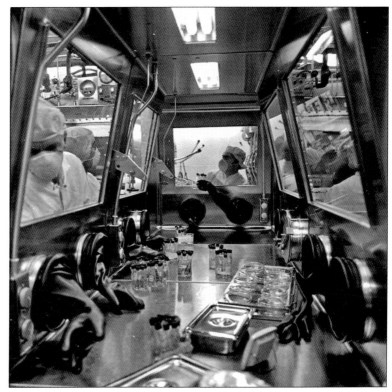

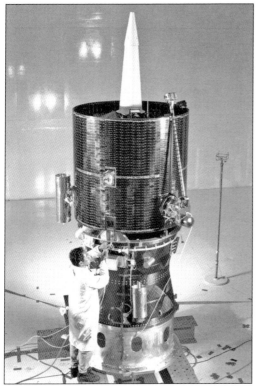

The Lunar Prospector mission, managed by Ames, is shown after assembly. The craft was sent skyward on January 6, 1998, from the Kennedy Space Center, Florida. The Lunar Prospector mission ended when Ames researchers collided the spacecraft with the moon on July 31, 1999. (Courtesy NASA.)

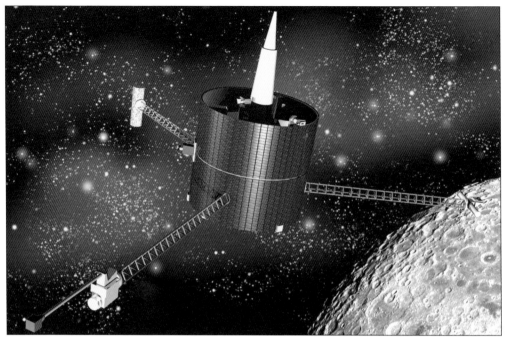

Lunar Prospector, shown in an artist's conception traveling through space, mapped the moon's mineral composition, gravity, and magnetic fields and determined that there could be water near the moon's poles. The theory is that subterranean water could be tapped to support a colony of researchers on the moon. (Courtesy NASA.)

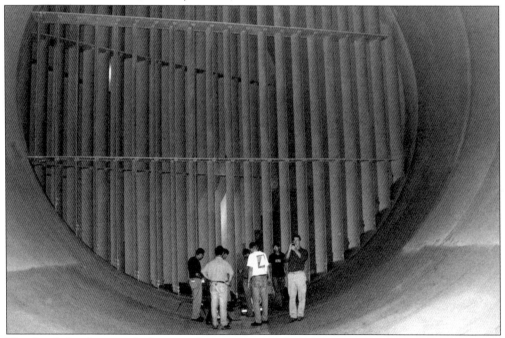

This low-light photograph shows workers inspecting the turning vanes in Ames's 12-foot wind tunnel. The size of the workers shows the volume of air moved through the wind tunnels during testing. (Courtesy author.)

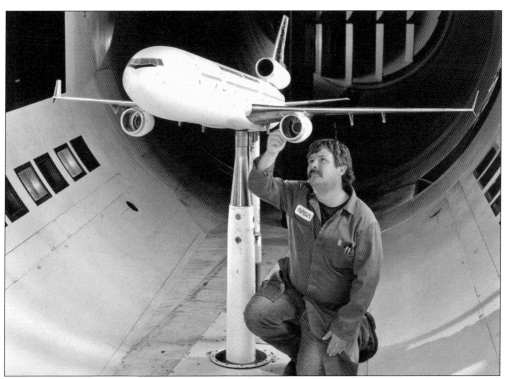

Most of today's modern U.S. airliner designs have been tested in the wind tunnels at NASA Ames. Here NASA technician Ron Strong inspects a scale model of the McDonnell Douglas (now Boeing) MD-11 three-engine jet liner. (Courtesy NASA.)

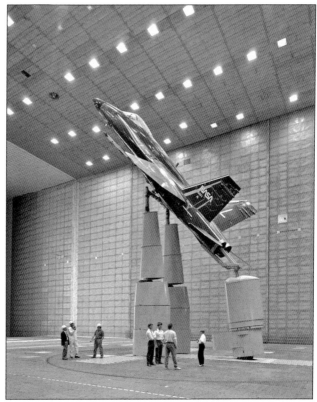

Early F/A-18 Hornet jets were having metal fatigue problems with their twin vertical tails. It was determined that vortices from the Hornet's wing-leading edge extensions impacted the tails during high angle of attack flight (in this case high nose up in relation to direction of flight). This former U.S. Navy Blue Angels F/A-18 was installed in the 80-by-120-foot wind tunnel for high angle of attack testing. (Courtesy NASA.)

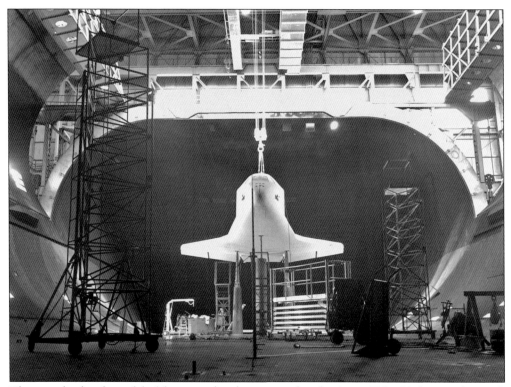

This one-third scale model of the space shuttle was tested in the Ames 40-by-80-foot wind tunnel. Models are lowered into the test section, and the top of the tunnel is then closed for testing. (Courtesy NASA.)

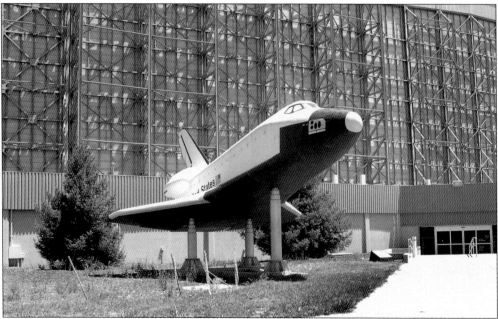

After testing, the one-third scale model was painted to resemble the space shuttle and placed on display outside Building No. 223. It is visible from R. T. Jones Road. (Courtesy author.)

Tragedy struck both the navy and NASA family on April 12, 1973, when a Navy P-3 (Bureau No. 157332) and NASA's Convair 990, "Galileo," collided in midair on approach to Moffett Field. Sixteen of the 17 crewmembers in both aircraft perished. The wreckage rained down on the Sunnyvale Municipal Golf Course across the freeway from the end of Moffett Field's runways. (Courtesy NASA.)

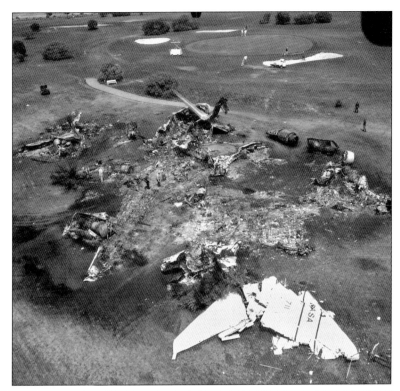

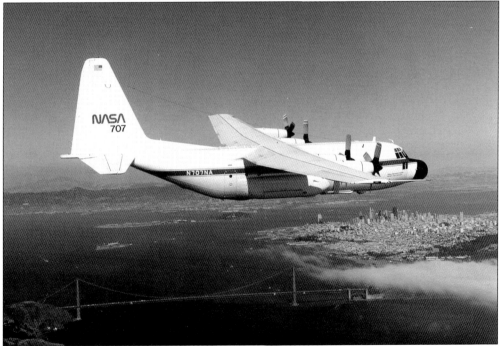

NASA NC-130B (ex-USAF 58-0712) flew from Ames on earth survey missions. During a series of wildfires in California, NASA 707 used infrared cameras to aid fire fighters in attacking the fire's hot spots. (Courtesy NASA.)

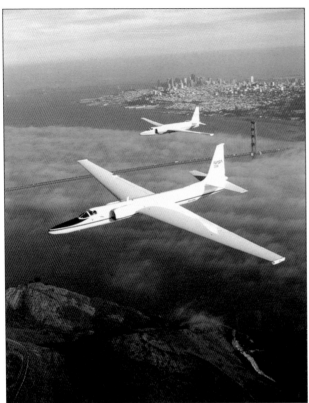

In 1988, NASA took delivery of its last new ER-2, foreground, an upgraded version of Lockheed's famed U-2, seen in trail over San Francisco and the Golden Gate. The following year, the space agency retired the U-2. ER-2s fly in support of NASA's Earth Resources program, photographing and sampling the earth and its atmosphere throughout the world. (Courtesy NASA.)

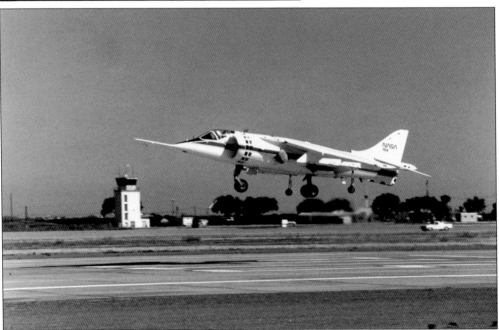

Vertical flight technologies have long been a focus at Ames Research Center. Here Ames–based YAV-8B Harrier, NASA 704, lifts off from Crows Landing auxiliary airfield, a satellite to Moffett Field in California's San Joaquin Valley. (Courtesy NASA.)

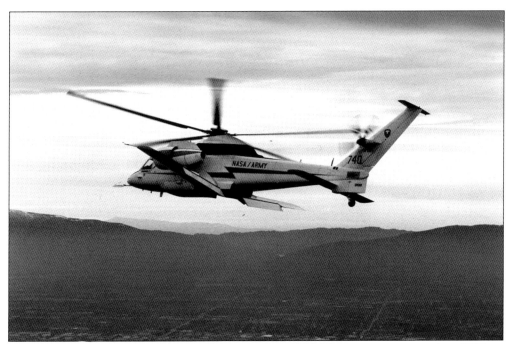

The Rotor Systems Research Aircraft was an Army/NASA project, conceived in 1970, to demonstrate the jet-powered flight of a helicopter with its main rotor blades stopped. Small wings and four large wide-chord blades (not shown here) were to form the flying surfaces, while two pod-mounted General Electric TF-34 engines provided thrust when the blades were stopped. The program ended in 1988. (Courtesy AC82-0089-7/NASA.)

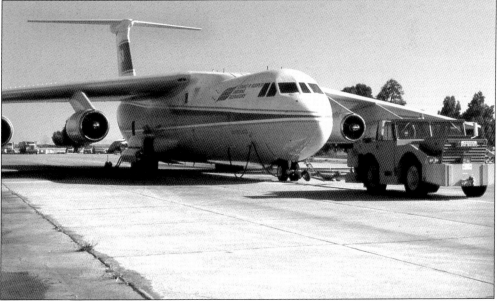

The Kuiper Airborne Observatory (KAO) was a Lockheed C-141 with a 36-inch telescope located forward of the wing. KAO began operations in 1974, and scientists aboard the aircraft made many discoveries, including the nine rings around Uranus, discovered March 10, 1977. (Courtesy NASA.)

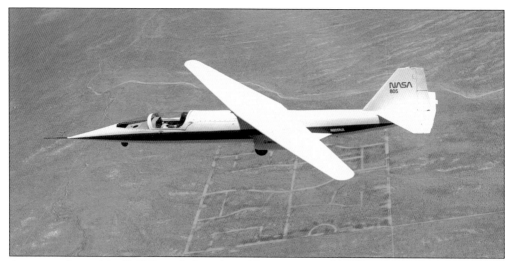

Ames aerodynamicist R. T. Jones believed an oblique wing could reduce drag at transonic speeds as well as increase fuel efficiency in supersonic aircraft. After building a series of models to test his theory, a proof-of-concept aircraft, known as the AD-1 (Ames-Dryden) was built and flown at NASA Dryden in Southern California. (Courtesy NASA.)

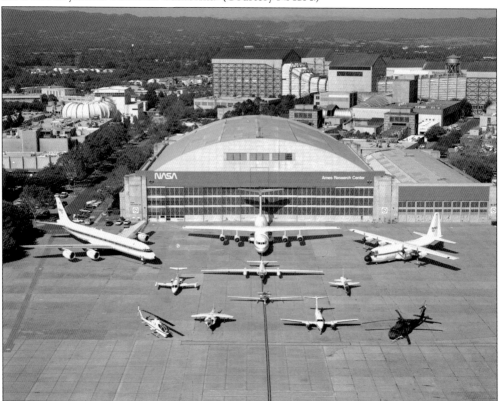

Pictured here in front of the Building No. 211 hangar on June 17, 1994, clockwise from top center, the NASA Ames Research Center's aircraft fleet are the C-141 Kuiper Airborne Observatory; C-130; T-38; UH-60; Beechcraft Kingair; Lockheed ER-2, with YO-3A in front; AV-8B Harrier; AH-1 Cobra; Learjet; and Douglas DC-8. (Courtesy Eric James/NASA.)

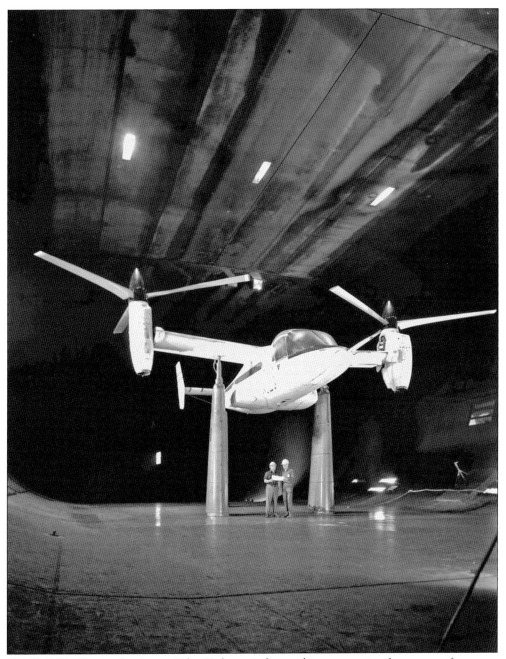

The Bell XV-15 is in the Ames 40-by-80-foot wind tunnel in preparation for rotor performance tests. This aircraft was built by Bell to Ames specifications under a NASA/U.S. Army program. Development of the XV-15 lead to today's Boeing V-22 Osprey tilt-rotor combat aircraft. (Courtesy NASA.)

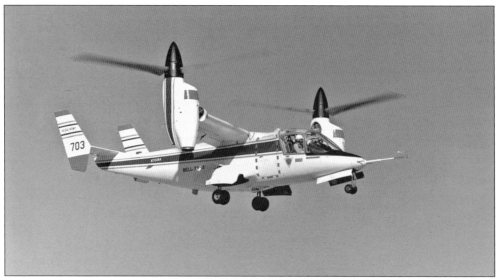

NASA 703, the second XV-15, was delivered to Ames in the summer of 1981 and was subsequently flown at Dryden Flight Research Center. In addition to flight handling characteristics studies, a variety of blade configurations were developed at Ames. (Courtesy NASA.)

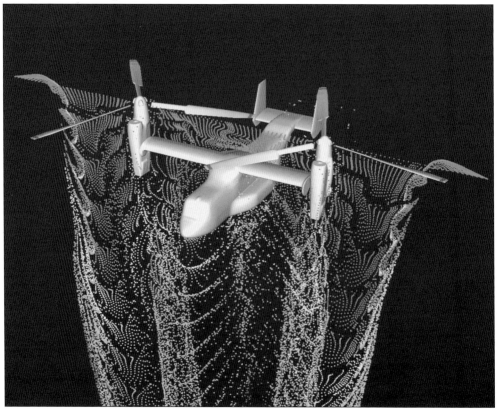

As computer power increased during the 1990s, the science of computational fluid dynamics (CFD) was advanced. Here the movement of air under the blades of a tilt rotor is modeled to help determine the aircraft's slow speed-flight characteristics. (Courtesy NASA.)

Frequently a highly modified SH-60 Blackhawk helicopter is seen hovering over Moffett Field. This aircraft is the Rotorcraft Aircrew Systems Concepts Airborne Laboratory (RASCAL), operated under a joint NASA/U.S. Army contract. Systems tested in this aircraft are used to improve commercial and military rotorcraft-handling qualities and in human-factors research. (Courtesy NASA.)

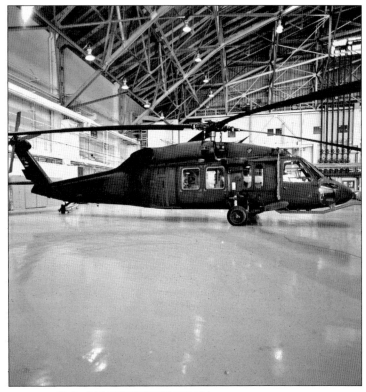

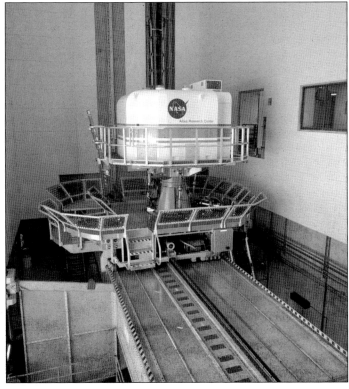

The Vertical Motion Simulator at NASA Ames Research Center features an interchangeable cab enabling four different types of vehicles to be flown. A short takeoff, vertical landing fighter; heavy lift helicopter; tilt-rotor aircraft; and the space shuttle can all be flown in the same building. This simulator is unique in that it recreates the six degrees of freedom movements of an aircraft—vertical, lateral, and longitudinal movement as well as roll, pitch, and yaw). NASA astronauts train in this facility, which can simulate a space shuttle landing airport anywhere in the world. (Courtesy NASA.)

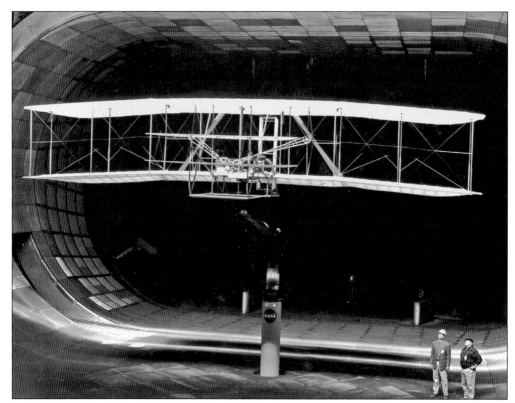

A Wright Flyer replica test took place in the 40-by-80-foot wind tunnel on February 19, 1999, in preparation for the 100th anniversary of flight in 2003. A number of replicas were built and their controls modified as a result of these tests. (Courtesy Tom Trower/NASA.)

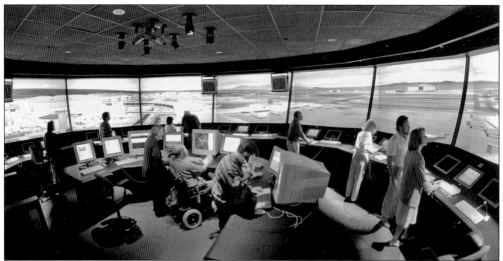

Future Flight Central (FFC), an interactive, 360-degree laboratory, was originally built to model air and ground traffic at major airports. FFC has been used by controllers from Atlanta, San Francisco, Los Angeles, and New York to improve operations and working conditions for controllers. Here controllers view an exact 360-degree simulation of the San Francisco International Airport. (Courtesy NASA.)

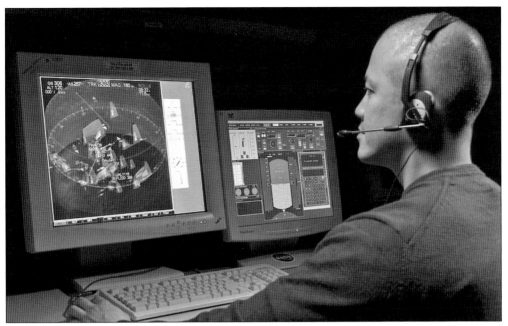

Another human factor/air space improvement technology developed at Ames is Cockpit Displays of Traffic Information, or CDTI. The system displays traffic to a cockpit crew in a three-dimensional format (shown here), profile, or in plan view. In addition, traffic is shown with speed and course, enabling cockpit crews to make fully informed traffic-avoidance decisions. (Courtesy NASA.)

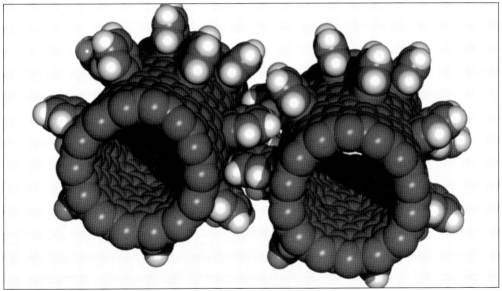

Developing machines composed of parts the size of a molecule, or smaller, has been a focus at Ames Research Center. Known as nanotechnology, Ames uses its supercomputers to study such concepts, such as the Fullerene Nanogears pictured here. A carbon nanotube, 1,000 times smaller than the width of a human hair, has had benzene molecules attached to the outside to form gears. When a laser charges the atoms, the shafts turn. The possible uses for such technologies are endless. Ames began the Center for Nanotechnology, which develops uses of the technology for future NASA missions. (Courtesy NASA.)

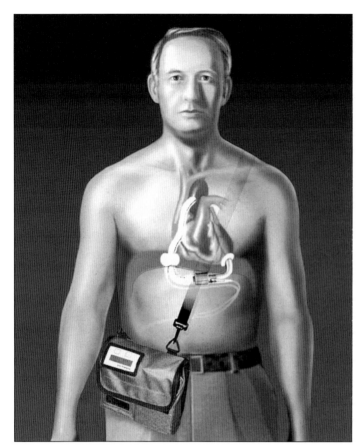

The DeBakey Ventricular Assist Device (VAD) was developed by Drs. Michael DeBakey and George Noon, along with researchers from NASA, and is being commercialized by MicroMed Technology of Houston. The VAD serves as a bridge for heart transplant patients and is powered by an external battery pack. (Courtesy MicroMed Technology.)

When the pump was first developed, it would run for a few days, but it damaged more red blood cells than an ailing body could reproduce. Scientists at Ames Research Center applied the same principles used to improve fuel flow in the space shuttle's main engine fuel pumps to blood flowing through the DeBakey VAD. An impeller and diffuser were added, and the DeBakey VAD can now assist a patient for more than six months. The MicroMed/NASA/DeBakey VAD has been implanted in more than 300 patients. (Courtesy NASA.)

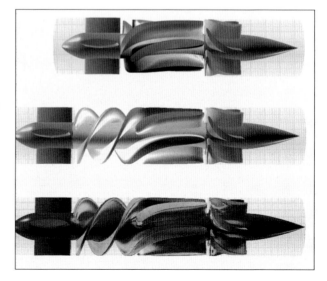

The Mars Exploration Rovers (MER), "Spirit" and "Opportunity," touched down safely on Mars in December 2003 and January 2004, in part due to their unique parachute assembly, tested in the 80-by-120-foot wind tunnel at Ames. The MER spacecraft deployed three parachutes this size during descent through the Martian atmosphere. (Courtesy NASA.)

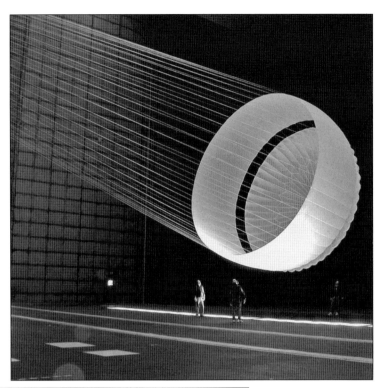

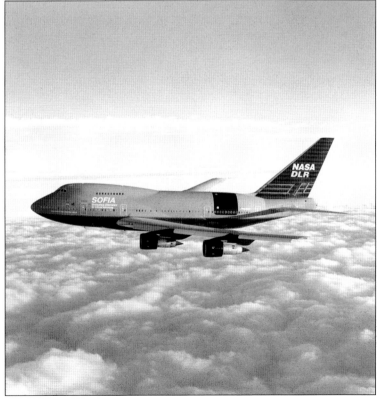

Ames Research Center will be home to SOFIA, the Stratospheric Observatory for Infrared Astronomy, in 2008. NASA has taken a Boeing 747SP and modified it to carry scientific instruments and a two-and-a-half-meter reflecting telescope. SOFIA will use infrared astronomy techniques to make its observations. (Courtesy NASA.)

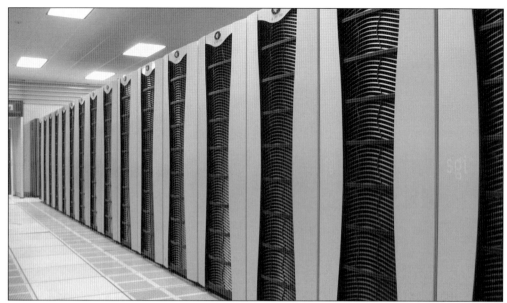

NASA, Intel, and SGI collaborated to develop the Project Columbia supercomputer, named after the crew of STS-107 Space Shuttle *Columbia*, lost February 1, 2003. This project is a model of government/industry cooperation and was conceived, developed, and installed in about 120 days. When up and running in October 2004, the 10,240-processor machine was the fastest *operational* supercomputer in the world, with more than 650 users performing real science. The machine's peak performance is rated at 62 trillion calculations per second! (Courtesy David G. Robertson.)

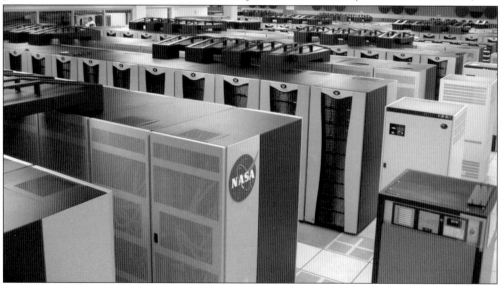

When Space Shuttle *Discovery* (STS-114) was on orbit in July 2005, debris from the external tank were studied using the supercomputer. Later in the mission, a thermal protection gap filler strip between two of the heat shield tiles was found to be out of place. NASA called on Ames Research Center to help determine the crew's safety and how the craft would perform with this problem. The Project Columbia supercomputer was used to determine the crew's safety. This computer is now being used to study such disciplines as weather, nanotechnology applications, and fluid flows around spacecraft. (Courtesy David G. Robertson.)

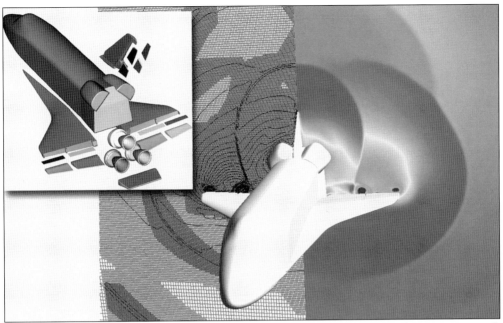

Computational programs, such as CART 3D pictured here, have been developed at Ames Research Center to enable scientists to more accurately model three-dimensional objects and to enable rapid changes to the object's configuration. Inset, the space shuttle is seen with its external components such as flaps, rudders, wings, and engine nozzles used to configure the model, while the main image shows the mesh required, left, to calculate fluid flow results, right. CART 3D automates the mesh generation portion of running a fluid dynamics computation. (Courtesy NASA.)

Scientists at Ames Research Center and Johnson Space Flight Center have collaboratively modeled the space shuttle from liftoff to orbit. This enables scientists to quickly simulate a configuration or event at any time during ascent. Computers were not capable of efficiently making such tremendous calculations five years ago. (Courtesy NASA.)

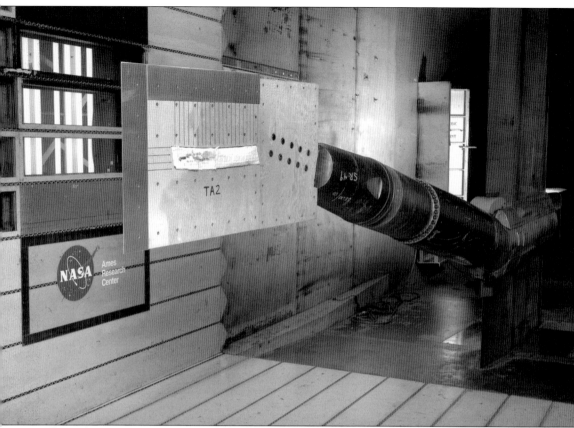

The 11-foot supersonic wind tunnel at Ames Research Center was used to determine the effects of a shredding thermal blanket on STS-114 during its July/August 2005 mission. After reviewing how the blanket would behave during reentry, simulated in the wind tunnel, NASA managers determined it did not need to be repaired in space, and the crew of *Discovery* could return home safely. (Courtesy Dominic Hart/NASA.)

Six

MOFFETT FIELD IN THE NEW MILLENNIUM

The closing of NAS Moffett Field in 1991, and subsequent transfer of property from the navy in 1994, saw NASA become responsible for the former military base and operations of its airfield complex. Two years later, the cities of Sunnyvale and Mountain View formed advisory committees to provide input to NASA about future uses of the former navy property. By 1998, NASA had developed a plan to use buildings in the Shenandoah Plaza area of the base to form the nucleus of a new research and development center.

On November 1, 2002, NASA cleared all the environmental hurdles and gave the go-ahead for development of the former navy property, to be known as the NASA Research Park. The space agency envisioned a shared-use research and development campus, primarily located on a 213-acre parcel of land encompassing Shenandoah Plaza and the property between the main gate, Highway 101, and the airfield.

NASA sought a number of colleges and universities to serve as anchor tenants for the research park. The University of California at Santa Cruz, San Jose State University, Carnegie Mellon University, and the Foothill/DeAnza Community College District quickly moved to establish campus sites in the NASA Research Park. This influx of high-technology educators was followed by a number of smaller technology companies, quickly filling many of the existing buildings. Carnegie Mellon University occupied Building No. 23, the former base dispensary, which is the first building on the plaza's south side when entering from the main gate.

On September 28, 2005, NASA announced a partnership with the Internet conglomerate Google to build a new company research and development campus. The memorandum of understanding calls for Google to develop one million square feet within the research park.

While NASA continues its development of the research park, the U.S. Navy and the Environmental Protection Agency, along with a myriad of other groups, including "SaveHangarOne.org," are working to find an agreeable solution to the hangar's negative impact on the surrounding area.

When the hangar was originally constructed, the metal exterior skin was sandwiched with asbestos and polychlorinated biphenyls (better known as PCBs). Now those contaminants are running off the exterior of the hangar and collecting in a storm runoff area known as Area 25. Asbestos and PCB levels in Area 25, which borders the San Francisco Bay, are extremely high. This situation was temporarily mitigated when the navy had Hangar No. 1 painted with an asphalt/paint mixture to, in effect, encapsulate the hangar's skin. Unfortunately only a temporary

solution to a long-term problem, the asphalt encapsulation needs to be reapplied as pollution levels are increasing (winter 2006). The navy is taking input from the public and other agencies and is expected to release its draft plan to mitigate the pollution by late spring 2006. The solutions range from continuing to recoat the hangar, to tearing it down, to reskinning it. Each has its merits and its shortcomings. For now, it's a matter of waiting to see what the navy presents as a solution.

Located in a former warehouse adjacent to Hangar No. 1, the Moffett Field Museum houses a tremendous collection of Moffett Field artifacts and photographs. Museum volunteers and docent guides give free tours through the museum, which is separated into themed areas dealing with each of the significant eras in Moffett Field history. For operating hours, directions, and additional information, contact the museum at www.moffettfieldmuseum.org.

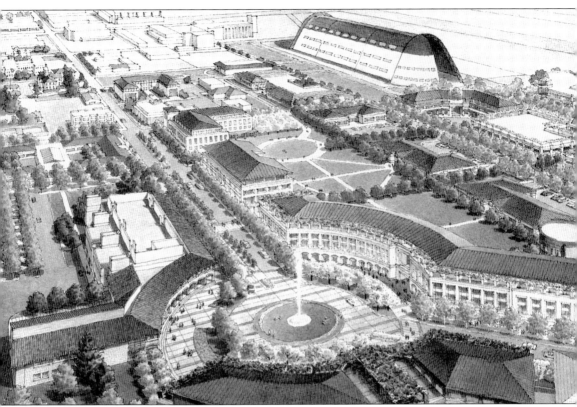

This is an aerial representation of how the future NASA Research Park will look when industry and academia have built their campuses. Buildings will maintain the historic district's Spanish Colonial Revival–style, giving a cohesive feel to the area. (Courtesy NASA.)

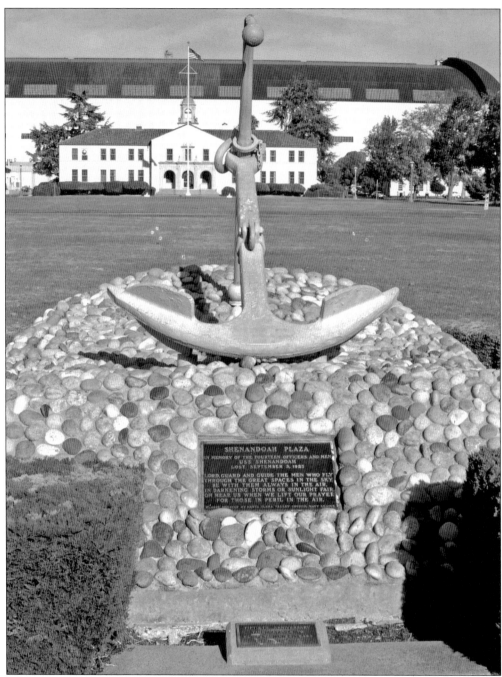

A memorial marker at the entrance of Shenandoah Plaza commemorates the loss of lives on the dirigible of the same name. The plaque reads, "In memory of the fourteen officers and men of the USS Shenandoah. Lost, September 3, 1925. Lord, guard and guide the men who fly through the great spaces in the sky. Be with them always in the air, in darkening storms or sunlight fair. Oh hear us when we lift our prayer for those in peril in the air." The memorial was donated by the Santa Clara Valley Council Navy League. The plaque at the bottom marks the 50th anniversary time capsule, slated to be opened on April 12, 2007. (Courtesy author.)

The base's sundial was presented to the air station by Navy Rear Adm. Ammen C. Farenholt (Medical Corps) when it was commissioned in 1933. Farenholt was Inspector of the Medical Department (West Coast) at the time the sundial was presented. The plate of the sundial reads, "United States Naval Air Station Sunnyvale California," and a presentation plaque is located near the bottom of the column. At the base of the sundial sits the 100-year time capsule, slated to open on April 12, 2033. (Courtesy author.)

A door on the backside of Building No. 19 gives away the former navy use of the inside offices. Customers and services of the Fleet Imaging Center Pacific are represented by film, a map, a stylized F-14, a missile frigate, and an attack submarine. (Courtesy author.)

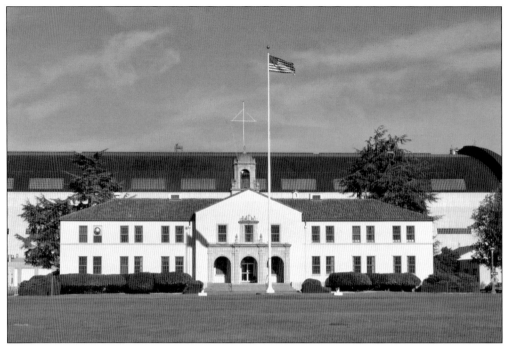

Dominating Shenandoah Plaza is Building No. 17, the former base headquarters. This was the first building constructed at the air station beginning in 1931. Notice the bell tower over the main entrance. The interior of the 19,000-square foot building is appointed with decorative Spanish tile, dark wood paneling, and wrought iron stairway balusters and handrails. In the former navy operations office is a huge wall-mounted topographic world map. (Courtesy author.)

A close-up of Building No. 17's architectural entryway detail shows column tops, dentil molding, and urns. (Courtesy author.)

This view shows the sandstone architectural details of Building No. 17. (Courtesy author.)

This is a view of the sandstone shield above the west entrance door of Building No. 20, on the southeastern side of Shenandoah Plaza. (Courtesy author.)

The column detail on Building No. 20 shows the intricate scrollwork. (Courtesy author.)

Building No. 25 served as the navy's theater and recreation center when the air station first opened in 1933. The two-story building, with a basement, comprises 24,300-square feet. The theater inside Building No. 25 can seat more than 200 people. (Courtesy author.)

The massive Building No. 2 was constructed as the free balloon hangar, where balloons would be inflated, baskets attached, and then walked to the flight line. The building is 63-feet tall and has 19,691-square feet of floor area. (Courtesy author.)

Built as the base aerological station, Building No. 18 later serves as the base communications station. Windows on the third floor offer a 360-degree view of the surrounding area. (Courtesy author.)

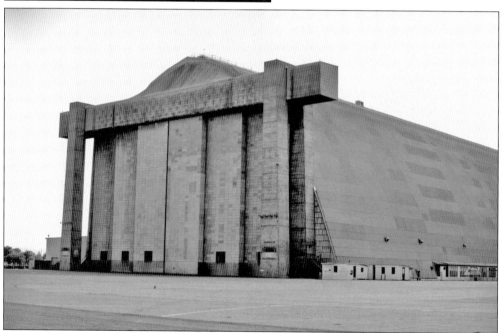

Across the runway to the east sits Hangar No. 2. Hangar No. 3, shown here, is a bit wider than Hangar No. 2. The door support columns are constructed of concrete. (Courtesy author.)

Weathered, but still visible on the southwest door support column of Hangar No. 3 are the squadron markings of Patrol Squadron 40, the "Fighting Marlins," and Patrol Squadron 46, the "Oldest and the Best." The bottom of the VP-40 insignia is more than 20 feet off the ground. (Courtesy author.)

The door support columns are accessible from inside the hangar, and also serve as air raid shelters. At some point in their stay, Canadian Patrol Squadron 407 left its mark inside Hangar No. 2 to commemorate its time at Moffett Field. (Courtesy author.)

This is an interior detail of Hangar No. 2's wooden structure showing the interior frame and exterior skin. The craftsmanship is certainly impressive in the way the boards are cut and fitted to the framework. (Courtesy author.)

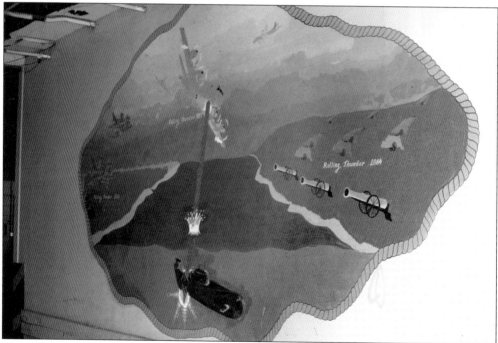

The walls inside Hangar No. 2 contain numerous murals left over from the navy squadron days at Moffett Field. On a vehicle access path, this mural depicts U.S. military participation in three different Rolling Thunder operations (1864, 1966, and 1987). The P-3 is spearing a Soviet submarine. (Courtesy author.)

SUPPLY
DEPARTMENT

The supply department in Hangar No. 2 operated around this mural of a P-3A. Hopefully some of the remaining squadron art can be preserved. (Courtesy author.)

Secure storage of documents and weapon sights was maintained in this massive vault room inside Hangar No. 2. The steel doors feature a two-key, combination lock. (Courtesy author.)

This is the former U.S. Navy Blue Angels F/A-18 Hornet that was mounted in the 80-by-120-foot Ames wind tunnel for a series of high angle of attack tests to model airflow from the Hornet's leading edge extension over the vertical tails (see page 89). The aircraft sits in storage in Hangar No. 2 for a future museum effort. (Courtesy author.)

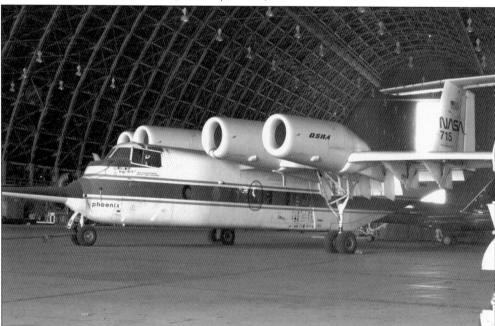

NASA's QSRA (Quiet Short-Haul Research Aircraft) began life as a deHavilland Canada Buffalo. After service with the U.S. Air Force (C-8A serial 63-13687), a new wing and engines were installed for operations at high-lift coefficients. The aircraft is also stored in Hangar No. 2. (Courtesy author.)

Displayed outside the base perimeter are three aircraft that served at NASA Ames and one remotely piloted vehicle. Pictured, from left to right, are an AV-8 Harrier, F-104 Starfighter, the HiMat technology demonstrator, and a U-2. In front of the U-2 sits the hub of a wind tunnel fan blade. (Courtesy author.)

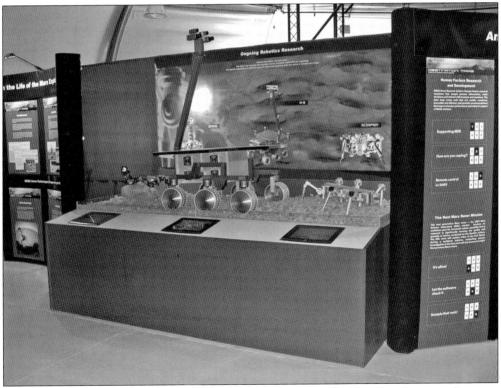

The Ames Exploration Center features displays of technologies developed at the research center, including autonomous robots such as the K-9 (a future Mars rover), snakebot, and scorpionbot. The center also has an immersive theater with a 40-foot wide, wrap-around screen. Other displays include historical space suits, a Mercury space capsule, and a variety of wind tunnel models. (Courtesy author.)

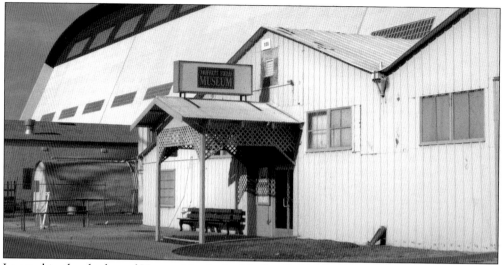

Located in the shadow of Hangar No. 1, the Moffett Field Museum is housed in Building No. 226. The nonprofit, educational group has transformed this former navy warehouse into an outstanding destination for curious bypassers and serious researchers. The museum is free to the public. (Courtesy author.)

The Moffett Field Museum's lighter-than-air display features a number of rare artifacts from the rigid airship days, including the "Flying Trapeze" artwork, which represents the F9C pilots who hooked onto the *Macon*. Uniforms and other accoutrements detail daily life during the airship days at Moffett Field. (Courtesy author.)

An ex-navy free balloon basket greets visitors upon entry to the Moffett Field Museum. Although the display dominates the entrance, it is surprisingly small by today's standards. The basket's wicker construction has withstood its career with the navy and its subsequent civilian service very well. Reportedly this basket served at Moffett Field during World War II. (Courtesy author.)

Naval Air Station Sunnyvale and *Macon* memorabilia on display includes identity disks, parking permits, and other items of the period. (Courtesy author.)

The Moffett Field Museum has acquired an extensive collection of books, technical publications, and photographs relating to lighter-than-air equipment as well as base history. The museum's library also serves as a conference room. (Courtesy author.)

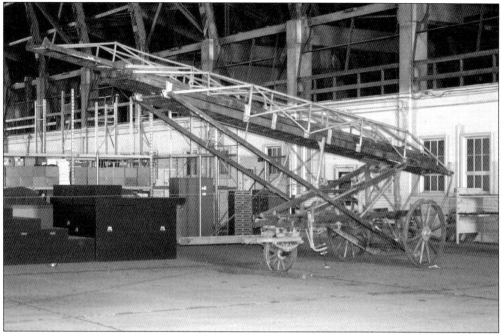

Stashed away in Hangar No. 2 is an extremely rare crow's nest extension ladder. Capable of telescoping 65 feet into the air, it was used to service the dirigibles and later navy blimps. The Moffett Field Museum plans to refurbish this artifact and display it when space becomes available. (Courtesy author.)

Pictured here is detail of the crow's nest ladder's guide wheel and wooden construction. (Courtesy author.)

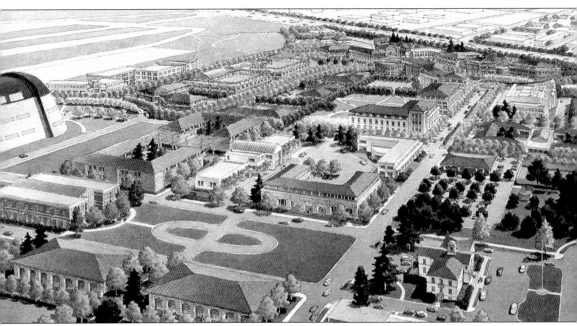

NASA Ames became responsible for the navy property when the service moved out in 1994. In 1998, after years of meetings with local governments and environmental reviews, NASA announced that the former navy property would become a shared-use research park where business and academia could be located with NASA for mutual benefit. Carnegie Mellon University, UC Santa Cruz, and San Jose State University moved to establish satellite campuses within the park, and a wide variety of biotech and information technology companies have collocated there as well. Recently Google announced an agreement to build a campus on the NASA Research Park property. (Courtesy NASA.)

Hangar 1 Siding Composition

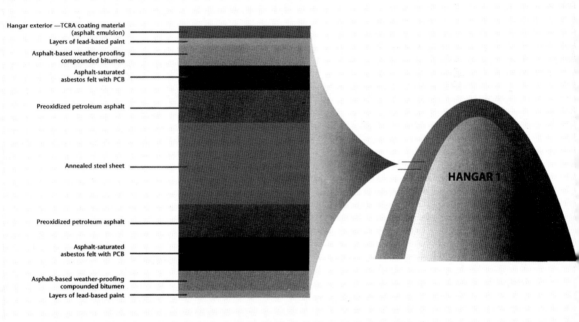

Hangar exterior —TCRA coating material (asphalt emulsion)

Layers of lead-based paint

Asphalt-based weather-proofing compounded bitumen

Asphalt-saturated asbestos felt with PCB

Preoxidized petroleum asphalt

Annealed steel sheet

Preoxidized petroleum asphalt

Asphalt-saturated asbestos felt with PCB

Asphalt-based weather-proofing compounded bitumen

Layers of lead-based paint

HANGAR 1

Hangar No. 1 was closed to the public in 1999 and remains sealed until the toxic coating of the hangar and interior PCB (polychlorinated biphenyl) contamination is addressed. The U.S. Navy has financial responsibility for the clean-up effort. This diagram shows the layers of contamination on both sides of the hangar's steel siding. The navy sealed Hangar No. 1 with an asphalt emulsion coating in 2002 at a cost of $3 million, but a long-term solution to has yet to be determined. Every time it rains, toxins leach off the hangar and into the bay wetlands. Thus the navy is under tremendous pressure to cleanup the site. (Courtesy U.S. Navy.)

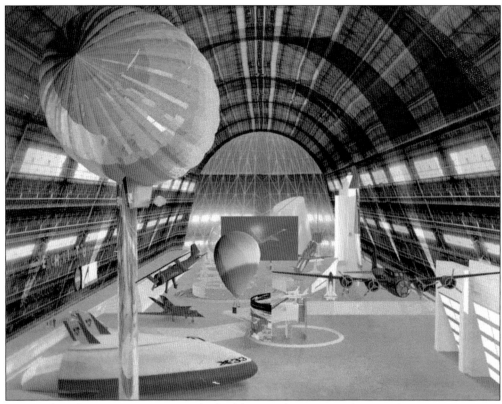

Future plans for Hangar No. 1 saw the building as the "National Air and Space Museum of the West." Artists conceptions were drawn, fund-raising began, and various aircraft were tucked away for future display until 1999, when the building was sealed due to health concerns. (Courtesy NASA.)

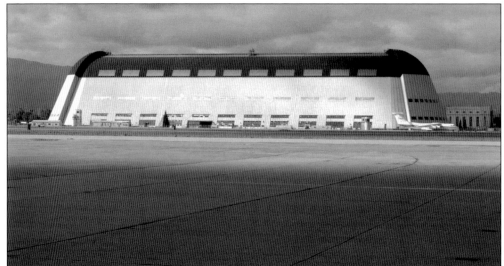

A dark cloud hangs over Hangar No. 1 as the structure awaits an uncertain fate at the end of 2005. The building dominates the south bay skyline and is seen by thousands of drivers on Highway 101 each day. The structure's future will be decided sometime in 2006. (Courtesy author.)

Building No. 200, headquarters of NASA Ames Research Center, is where the decision makers for Moffett Field reside. It was inside this building that the fortuitous decision to turn the former navy property into the NASA Research Park was made, preserving the base's wonderful Spanish Colonial Revival architecture and its history.

DISCOVER THOUSANDS OF LOCAL HISTORY BOOKS FEATURING MILLIONS OF VINTAGE IMAGES

Arcadia Publishing, the leading local history publisher in the United States, is committed to making history accessible and meaningful through publishing books that celebrate and preserve the heritage of America's people and places.

Find more books like this at
www.arcadiapublishing.com

Search for your hometown history, your old stomping grounds, and even your favorite sports team.